CHARACTER DESIGN QUARTERLY

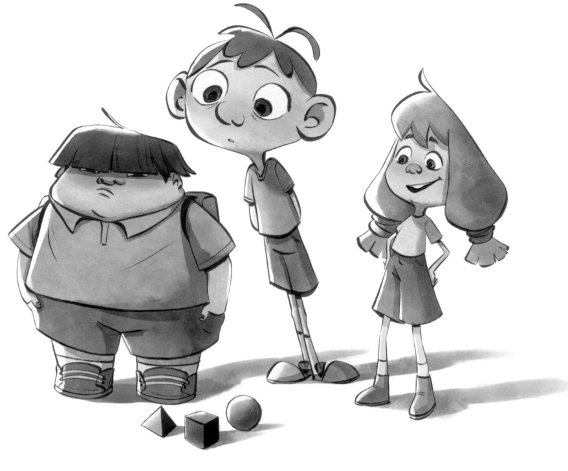

Image © Lea Embeli

CONTENTS

WELCOME TO *CHARACTER DESIGN QUARTERLY 24*

Every artist has their own unique story to tell about how they discovered their passion and how their career has developed, and this issue's cover artist, Nathanna Érica, is no exception. She provides an incredible in-depth tutorial on how she created the beautiful paper-craft cover, and we ask questions about her fascinating journey from qualifying as a lawyer to landing her dream job, illustrating for Disney.

As usual, we have a wide range of tutorials from great artists. Marta Andreeva shows us how a character's pose can change their emotional state, Tata Che brings a creepy coven of witches to life, and Lea Embeli shares tips about how to design characters for young children.

We also had the great pleasure to speak with The SPA Studios – the Spanish animation studio behind the award-winning feature film *Klaus* – about their unique approach to 2D character design, and with Chaaya Prabhat, whose colorful illustrations brighten up the pages of a growing list of children's books.

We hope you find lots to inspire you in this issue of *CDQ* and enjoy adding your own unique spin to the many ideas inside!

SAM DRAPER
EDITOR

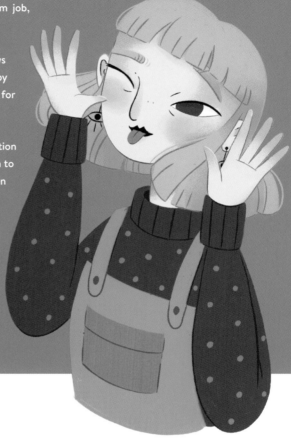

Image © Raquel Ochoa

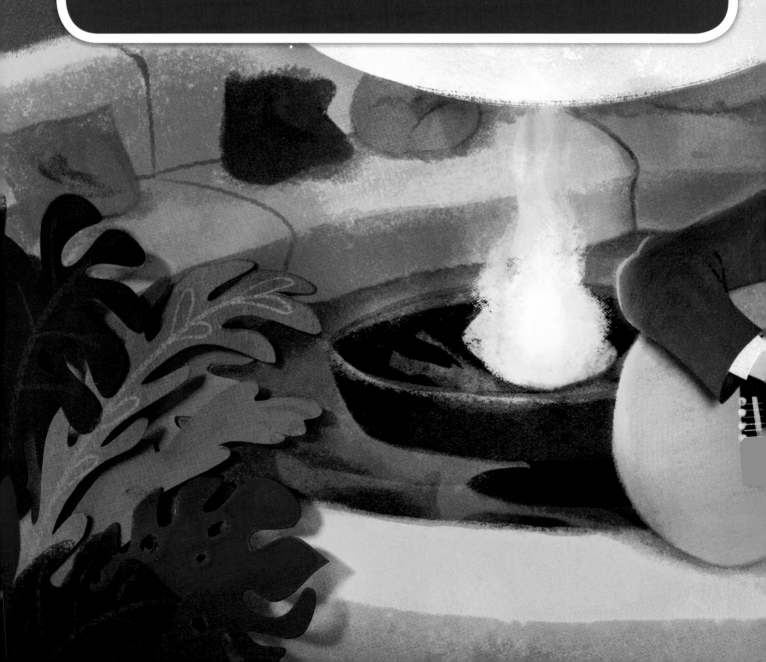

BEHIND THE COVER ART
NATHANNA ÉRICA

This issue's cover was created by Brazilian artist Nathanna Érica. After previously featuring a stunning paper-craft tutorial that Nathanna created for us, we couldn't wait to see what she'd create for a cover. As well as showing us the fascinating process behind the cover image's creation, Nathanna speaks to us about her surprise career change, the influences behind working with paper, and how she ended up in her dream job at Disney.

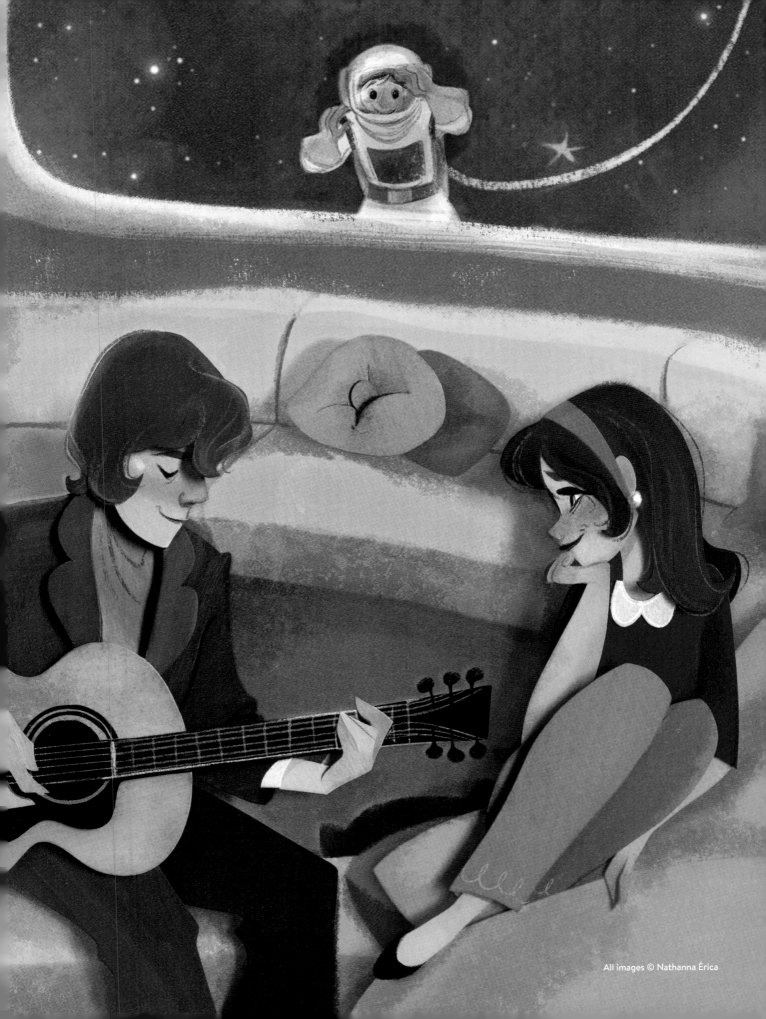

Hi Nathanna! Could you start by telling our readers a little about your career to date?

Hello, it's so exciting to be here. People often don't believe me, but my original choice of career was actually very different – I'm a qualified lawyer! I went to law school and have a bar license, but it just wasn't to be. A few years ago, I decided to pursue art full-time and started drawing incessantly, just as I did when I was a kid, focusing exclusively on my art and sharing it online. Now, I feel like I'm living the dream and truly blessed to be able to dedicate my time to what I love. I owe everything to the faith of people who trusted in me, allowing me to work on incredible projects despite my lack of formal training. It's been three years since I started working with Disney, initially here in Brazil for The Walt Disney Company, and currently with Disney Publishing Worldwide. I still can't quite believe it!

Your character designs are full of emotion and say so much in a single image. Do you have any tips for conveying so much in just one drawing?

Thanks, that's great to hear! I guess that is a goal of mine when it comes to my work, to try and show a story moment or a character's state of mind in one image. I think it comes from having worked as an animator in the past – trying to convey a feeling through movement and performance – except now I'm just trying to distill all that energy down into a single key drawing.

I think the secret might be to convey something very simple but put every part of the character into it. For example, take an emotional state such as anger — the character's pose and gesture, combined with the facial expression and the subtleties of what the hands and eyes are doing, will all help to build up that feeling you're trying to convey. If everything is working in harmony, then the emotion should come through for the audience. It will feel like a lot is happening while the statement or story is really something very simple. Fundamentally, it's all about feeling and conveying that one statement with absolute clarity.

These pages: *Hairstyling* – Art from the 18th Century has always fascinated me; the exquisitely intricate style of the Rococo era just begs to be recreated with paper

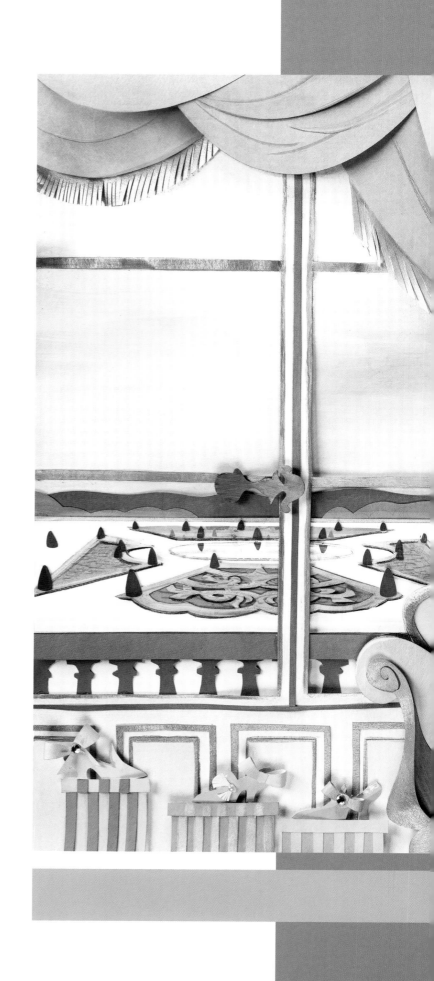

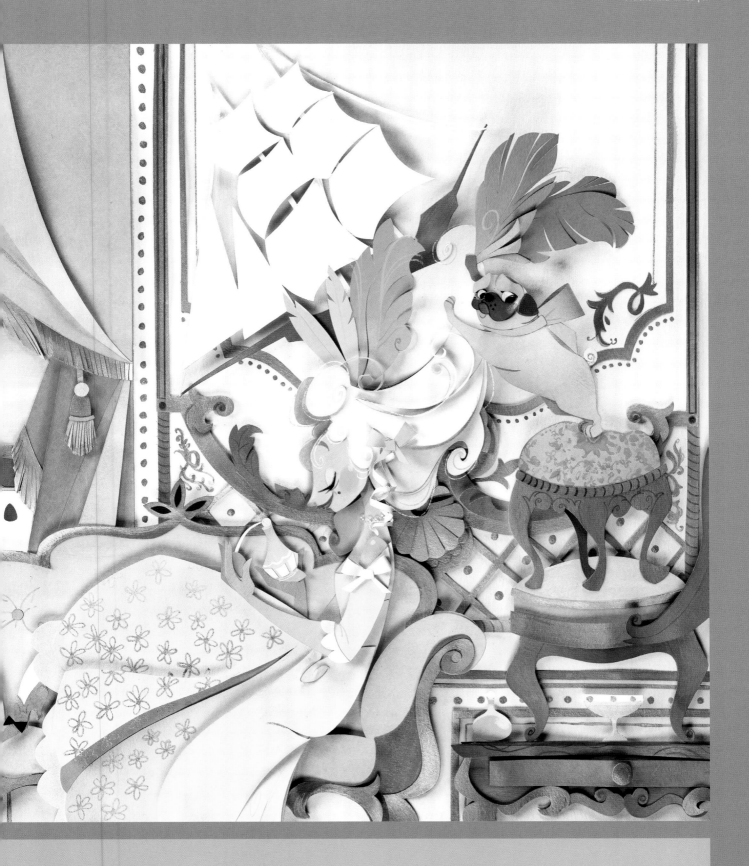

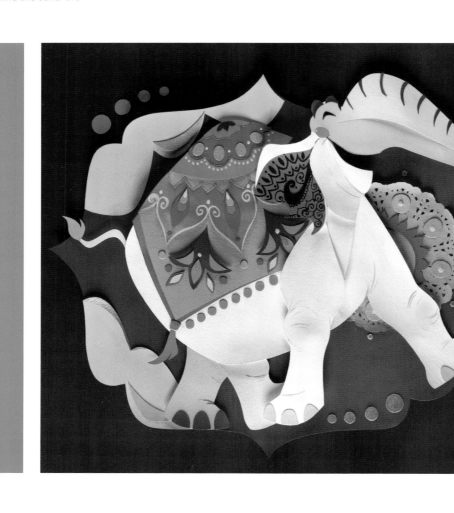

This page:

Jolly boy – Many of my pieces feature animals that I'd love to have as a best friend, such as this jolly elephant. I'd be by his side 24/7!

Opposite page:

Tiki mermie – The Tiki aesthetic is one of my favorite sources of inspiration. The richness of color and patterns translates perfectly to paper art

Let's discuss paper craft. How did you get started with this medium and what are the advantages of working with it?

Experimenting with paper art was actually the first step I took towards changing careers. I was very unsatisfied with what my professional life was shaping up to be. I started looking at these very intricate paper crafts on Pinterest, just out of curiosity, and I remembered that as a small child I loved cutting images from magazines and creating collage illustrations. After that, one thing led to another and I discovered amazing artists who have now become my guides, such as Mary Blair, Eyvind Earle, Irving Harper, and Brittney Lee, just to name a few.

Paper crafting is so incredibly satisfying – what I love the most is the "realness" that it lends to the artwork. Some of the advantages of working with paper are the textures, the layers, and the infinite ways you can play with shapes and colors, all while creating a 3D look.

Do you prefer using paper or working digitally?

Playing with paper will always be my passion. It's what got me started in pursuing art as a career – not just a hobby – so it will always have a special place in my heart, but I've come to favor the combination of both techniques. There's so much that can only be achieved with paper (and basically any traditional medium), but its magic can be enhanced tenfold when combined with the endless possibilities of digital art. For example, in my recent works as an illustrator, the clients specifically wanted my paper art to take center stage, but in terms of an entire book made with paper, I would only be capable of delivering what they expected with the help of technology.

The natural world seems to be a big part of the inspiration behind your designs. Where does this passion come from?

I've always loved playing in the garden and being in contact with nature. I'm an only child, so I would often create whole stories while playing alone, with only my grandma's trees and flowers for friends. It was around that time, when I was four or five years old, that I started drawing almost non-stop, day in and day out. Issues related to the environment have always affected me deeply. While I know there's not really much I can do to help, I take comfort in at least trying to create art that shows how beautiful our planet and all the animals that share it with us are, and how essential it is to keep them safe.

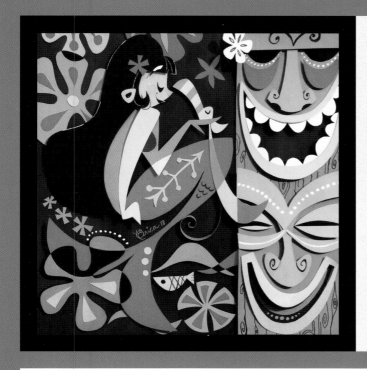
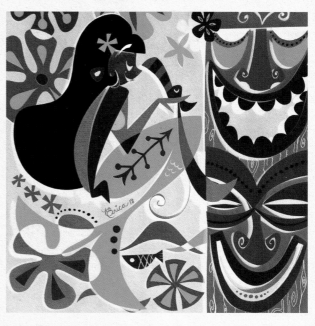

How did you the opportunity to work with Disney Books come about?

I think it was a combination of being in the right place at the right time and a lot of stubbornness on my part. At first, my family was a bit hesitant about me quitting my very short-lived legal career, but I was determined to try my best and eventually make a living as a professional artist. I started attending art conventions and accepting freelance jobs until, one day, I was spotted by… let's say, my fairy godmother – and she happened to work for Disney here in Brazil. She invited me to collaborate on a truly wonderful project for the celebration of *Cinderella*'s 70th anniversary. Because of my contribution to that project, I suppose I was on Disney's radar. I grew up during the Disney renaissance, watching masterpieces like *The Little Mermaid*, *Beauty and the Beast*, and *The Lion King* so this is all still mind-blowing for me and, quite frankly, so much more than I could possibly have dared to wish for.

What are the main influences behind your art style?

I was asked this question a few years ago, back when I was still trying out styles and discovering my passions, and I didn't know how to answer. I had an idea of the aesthetic that pleased me the most, but nothing too defined. Nowadays, I can say that my art style draws from the vintage look of children's picture books, especially from the 50s and the 60s, back when artists such as Mary Blair and Alice and Martin Provensen were gifting the world with their delightfully whimsical art. I adore how collages and heavily stylized characters were a big part of their works. For example, the absolute masterpiece that Mary Blair designed for the "It's a Small World" Disneyland attraction is a big influence. So, basically everything that has a vintage, mid-century feel to it, and transports you to a colorful place right out of the Little Golden Books series. That's what I love, and hopefully my own art can be enjoyed in the same way.

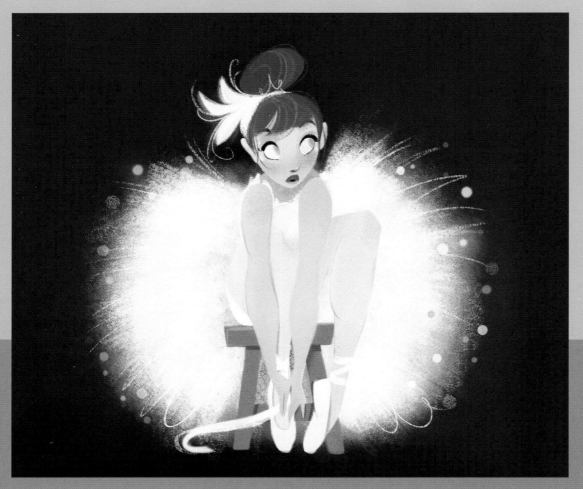

This page:

Preparation – The last few moments of preparation before our ballerina leaps onto the stage

Opposite page:

Beach babes – What started as a kind of self-portrait became an artwork inspired by colorful mid-century adverts

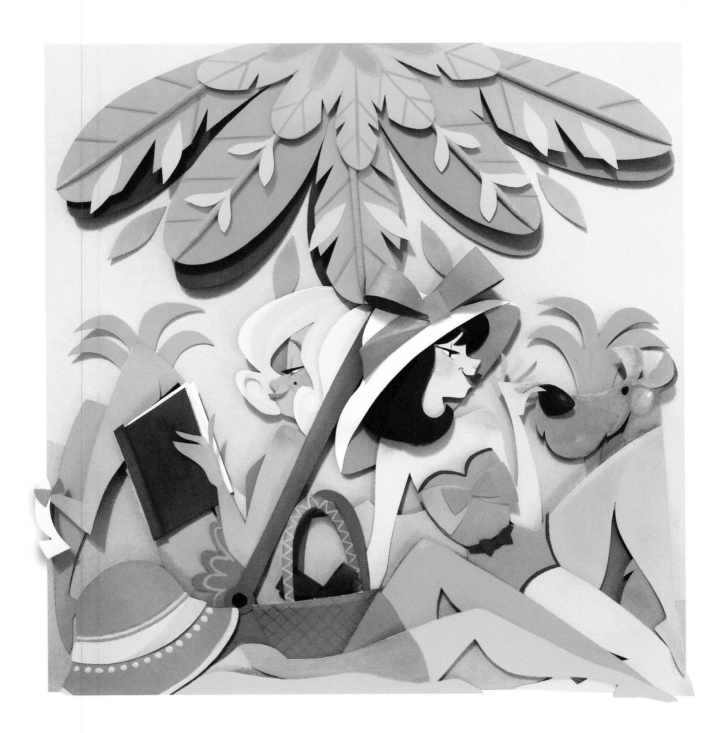

Thanks for speaking to us, Nathanna. Are there any projects coming up you'd like to share with us?

I have some projects lined up that'll keep me busy for the next two years or so, and that's the best kind of busy I could possibly ask for. There's a new *Frozen* picture book that has recently been released, and a series of Disney Villains books that will be published throughout 2023. There's also another project that I don't think I can get into too much detail about yet, but I will say that it's related to my love for old Hollywood films. So, please be on the look out for that – you'll know it when you see it!

Finally, I'm proud to say I have fulfilled my dream of being a children's book illustrator, which is an industry I've always admired, even when I was still studying Law. As for what the future holds, I can only wish for the chance to keep doing what I love. Hopefully, I'll continue to make art that can bring a little color and happiness to people's lives, which is why I wanted to become an artist in the first place. Thank you so much for having me!

CRAFTING THE COVER

This tutorial will be one big journey, in which I'll show you how to create a mixed-media artwork, combining paper craft and digital painting. For the digital part, I use a Wacom Cintiq 22HD Touch pen display, and for painting the scene I use Adobe Photoshop. Keep in mind that other tablets and pen displays, as well as different digital software, will also be perfect for this tutorial. As for the paper crafting, Canson Mi-Teintes is my favorite construction paper. It's very smooth, but resistant to gouache, watercolor, and other water-based pigments – not to mention its excellent texture on both sides. For tracing, any see-through paper is good – if you have a light table, that's even better! All the paper pieces were photographed with a Canon EOS Rebel SL3, but any great camera will do wonders for your art. I also use an assortment of pencils, scissors, and paints. So, take all the art supplies you have and let's get started.

YOUR SKETCH KNOWS WHICH WAY TO GO

As with basically any work of art – be it a drawing, a song, or a piece of writing – the very first step is to put your ideas in order. In this case, the best way to refine all the many thoughts that may initially seem overwhelming is by sketching them out. Start very loosely at first, as if you were trying to remember a dream. For this very first digital sketch, I use a pencil-like brush that resembles a real 2B pencil, which is a wonderful tool for sketching. Don't worry if your drawing looks messy for now.

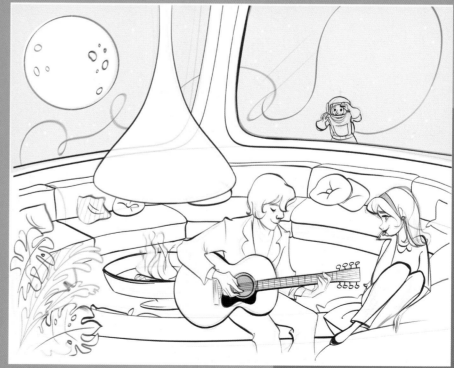

COMPOSING YOUR SCENE

Now we can set about cleaning up the sketch. When working digitally, you have an immense assortment of tools at your disposal. They allow you to properly polish up your layouts and find the perfect composition for your scene. You can move characters using the Move tool, resize them, adjust the perspective of your environment, and so on. Once all elements are in place, it's time to start inking your sketch. At this stage of the process, an ink brush is essential. Be sure to have the Shape Dynamics (in your Brush Settings panel) turned on and also the Transfer and Smoothing features if you'd like a more watery and pressure-sensitive brush. You may be wondering why a clear and easily readable sketch is necessary – this brings us on to the next step.

THE PAPER PROCESS

With the layout ready, the fun part begins: painting! However, this isn't just any normal painting – we need to add the paper pieces to the sketch. Print your layout (A4 size is ideal) and, using tracing paper, trace the sketch with a 4B (softer and darker) pencil. Next, flip the tracing paper and trace it again, but this time onto your Mi-Teintes papers, so that the sketch is transferred to them. The drawing will be flipped, but don't worry – the front of the paper will be intact and the back is only used as a guide for you to cut around your shapes.

Once all the parts have been transferred to the construction paper, it's time to cut them – it's up to you whether you paint the parts, or use them as they are. The variety of colors is often limited, so painting with gouache may be preferable if you want to add detail. Finally, start putting the pieces together, with only a tiny amount of glue to avoid causing any damage.

Opposite page (top): Initial ideas, sketched digitally with a soft black pencil brush, set to 40-50% opacity

Opposite page (bottom): After sketching your many initial ideas, it's now time to start cleaning them up

This page: Using the printed sketch as a guide, the paper pieces are now ready to be assembled

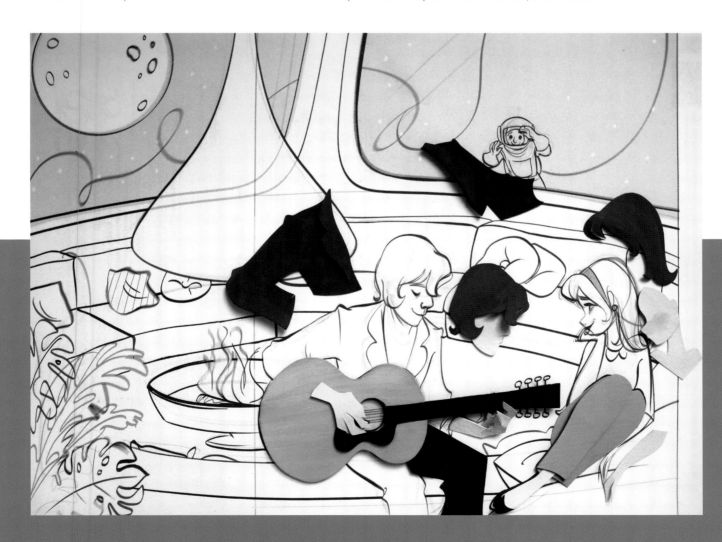

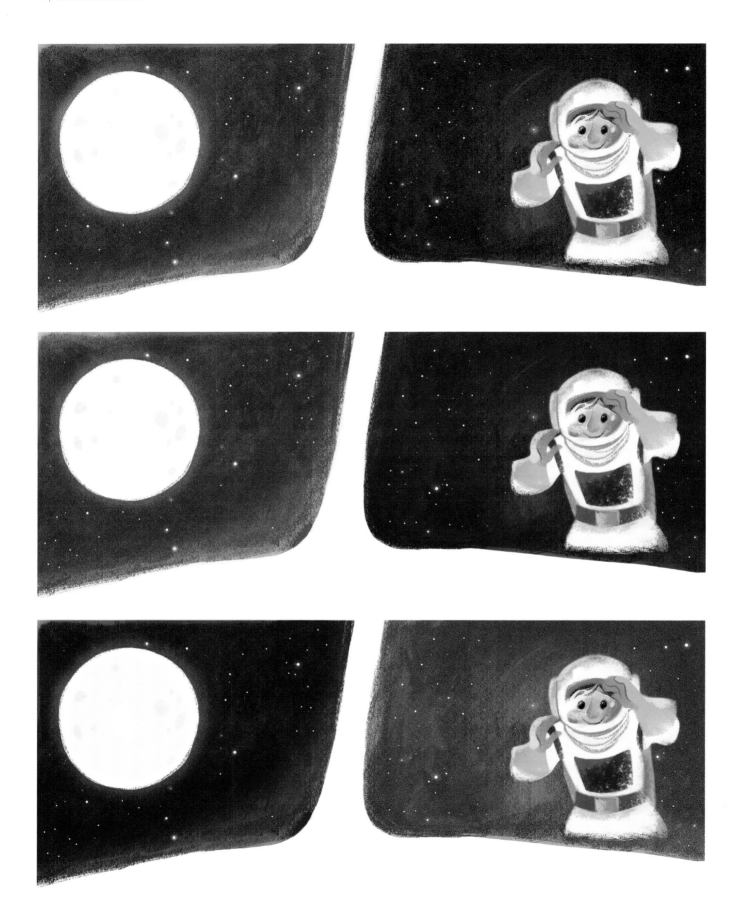

"THE GREAT THING ABOUT MIXING DIGITAL ART AND PAPER CUTTING IS THE INCREDIBLE SENSE OF VOLUME IT PROVIDES"

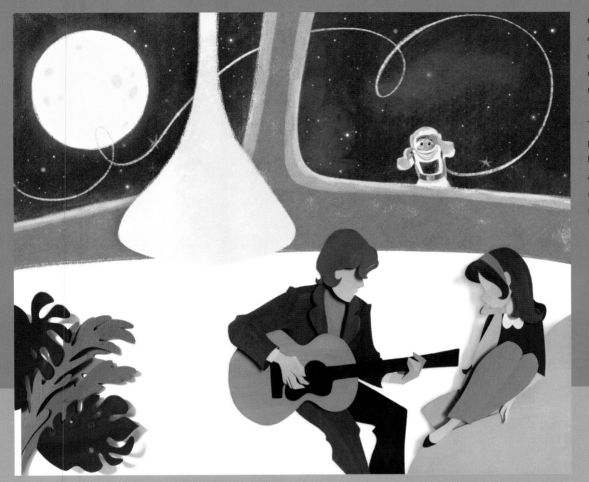

Opposite page: A little color exercise is always great to get warmed up and help you find the ideal palette

This page: After the paper pieces have been photographed and digitally cleaned up, they are ready for the final rendering

THE STARS LOOK DIFFERENT TODAY

It's time to go back to working digitally, photographing the paper pieces and adding them to the painting. But before all this, let's try out some color combinations. The colors you choose will set the tone for the entire piece. Is your scene going to be predominantly warm or cool? In this particular illustration, it's a night scene, with the moon shining bright and lots of stars, so it's safe to say that cool colors will be present. With this in mind, a little color exercise is very helpful. Don't be afraid to go wild! The result that pleases you the most is often the one you least expect. I choose a bold combination of colors that fit nicely with the contrast between the futuristic, retro, and mid-century elements of the layout.

CAPTURING THE MOMENT

You should now have chosen a color palette. I decide to go with a mostly complementary scheme (colors opposite each other on the color wheel). Next, we add the paper pieces. The great thing about mixing digital art and paper cutting is the incredible sense of volume it provides. In order to translate this volume into your artwork, the paper pieces need to be photographed. It may seem a bit tricky at first, but even a cheaper camera with a good lens (like the Canon EF-S 18-55mm) can achieve the desired result. Be sure to use plenty of natural light and take your photos against a white surface. Make corrections on Photoshop and, most importantly, clear out all the unnecessary parts of the photo (like the background) using tools such as the Magic Wand and the Lasso. It's as if you're cutting the pieces all over again, so take care not to remove too much of the white bits and end up cutting into the art.

"I LOVE GIVING MY ILLUSTRATIONS A VINTAGE LOOK, LIKE A WORN-OUT CHILDREN'S BOOK"

A SPACE ODYSSEY

With all the pieces in place, it's time to start rendering your artwork. The paper art needs to blend in, so smooth the edges, add detail to the characters (face, hair, clothing, light, and shadow) and make them a part of the scene. I love giving my illustrations a vintage look, like a worn-out children's book, and for this, the use of textures such as a grainy layer or a scanned page of an old book can look wonderful when added on top of your painting. Be sure to make the most of the many blending modes, especially Multiply for shadows, and Overlay and Soft Light for light and contrast. As for the painting itself, textured brushes create a vintage look. They resemble crayons – mostly gouache brushes with extremely textured tips – which gives the painting a scratchy feel, as if you could almost touch it. The Lasso tool can certainly speed things up, but if you have time to carefully paint each element, the brush strokes will make your artwork look incredibly real. If you're happy with how it turned out, congratulations – you've really made the grade!

These pages: The artwork is now complete, with the paper art blended into the painting using textured brushes and adjustment layers for light and shadow

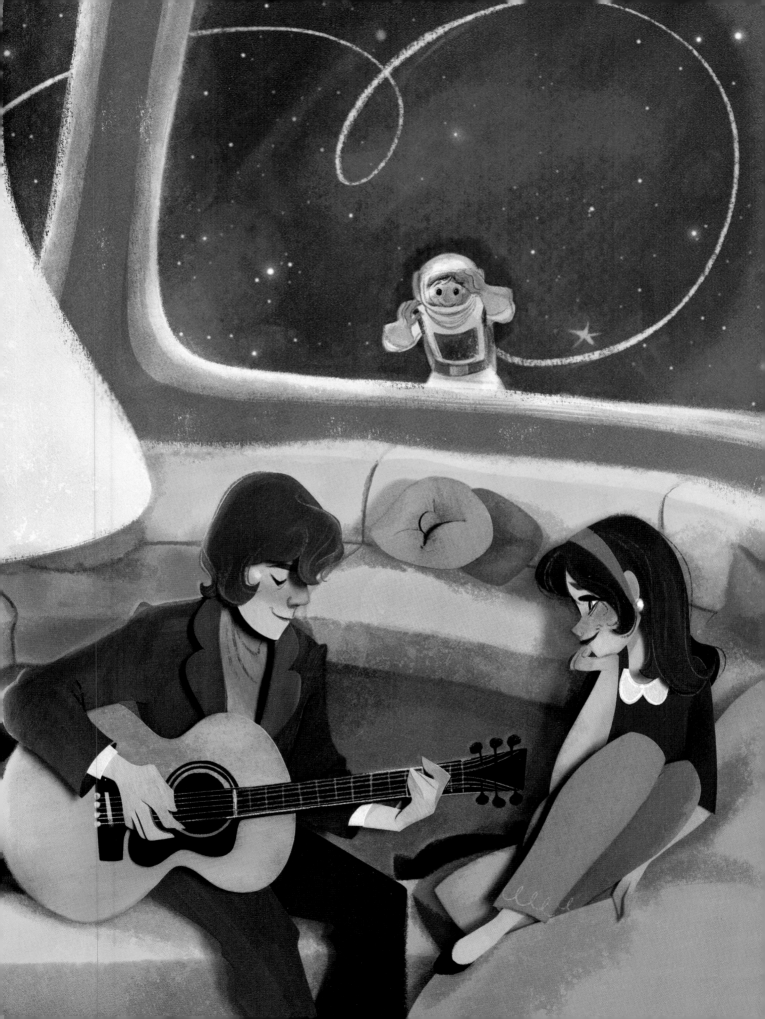

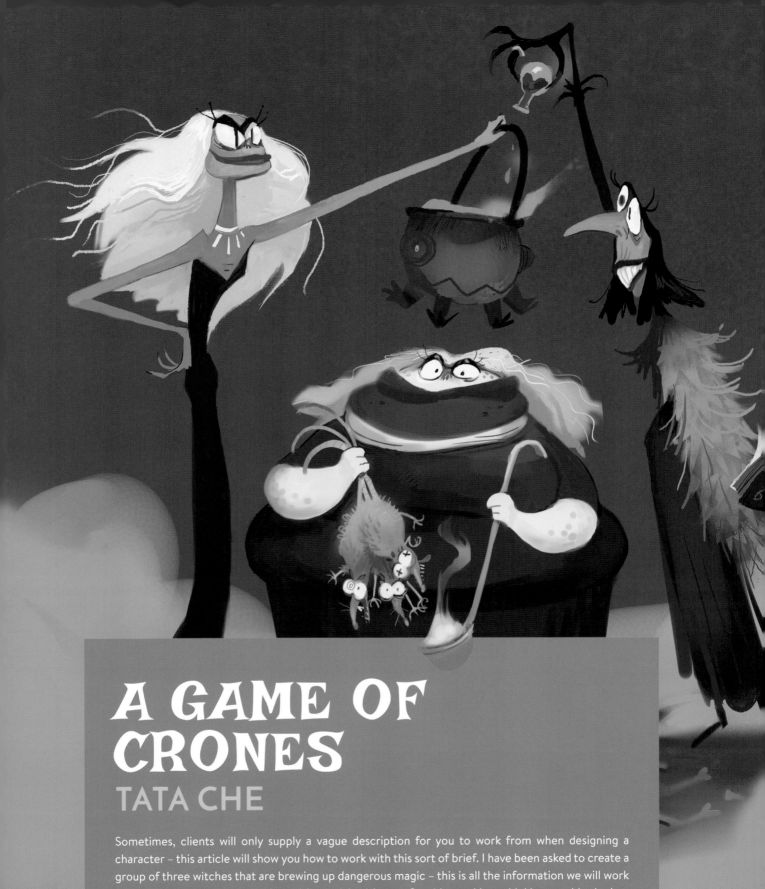

A GAME OF CRONES

TATA CHE

Sometimes, clients will only supply a vague description for you to work from when designing a character – this article will show you how to work with this sort of brief. I have been asked to create a group of three witches that are brewing up dangerous magic – this is all the information we will work from. I'll show you how it can be a risk to stick with your first idea and how thinking outside the box and conducting research can lead to interesting designs.

THREE BECOME ONE

The first group design I draw is three sisters with the same red hair and an Art Nouveau influence. The contrast between their silhouettes is low, each just different enough to appear unique. I draw upon the Indian dance influence to portray them as a tight group – it's hard to see where one character ends and the next begins. The long hair also makes us think of the group as one large character. Hiding parts of the face behind the hair is a symbolic way of suggesting these characters have a dark secret...

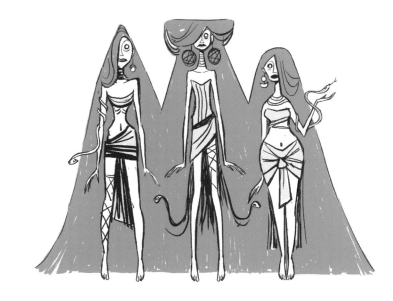

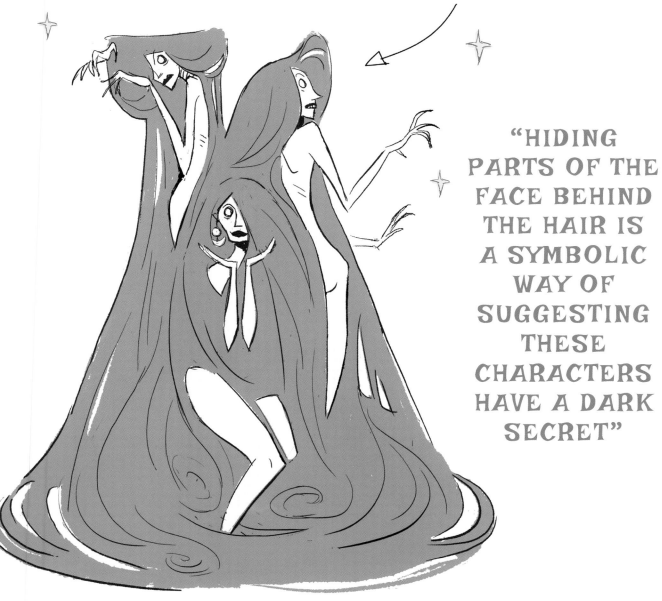

> "HIDING PARTS OF THE FACE BEHIND THE HAIR IS A SYMBOLIC WAY OF SUGGESTING THESE CHARACTERS HAVE A DARK SECRET"

HIDDEN FACES

As humans, we pay a lot of attention to each other's faces. It's how we read the emotions and intentions of whoever we meet. Witches are often thought to be dangerous beings, so the next association I make is with the tradition of hiding faces behind masks. I research mask ideas from lots of different cultures. Masks give a character an abstract look and leave the viewer wondering who they are, how old they are, and so on. Masks will make the witches seem even more mysterious and unknowable.

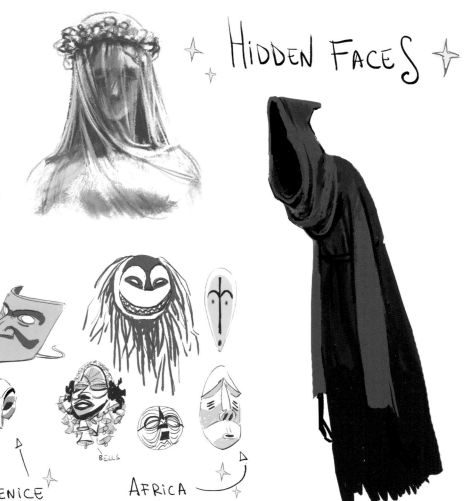

GREECE

VENICE

BELLS

AFRICA

VENICE WITCH

I'm obsessed with Italian culture so I want to try using the Venice carnival as an influence for my masked witches. Revellers at this carnival are fully draped with cloth and their faces are hidden behind masks – there is no skin visible at all. It's another great way to add mystery, as the viewer is left to imagine what's hidden beneath their clothes.

These characters look rather abstract as they start to lose their age and sex beneath the clothing. I imagine these witches could be million-year old witch goddesses! While researching masks, I found an African mask with bells around the face, an idea I think will suit my design. I can even imagine the sound these witches would make when moving.

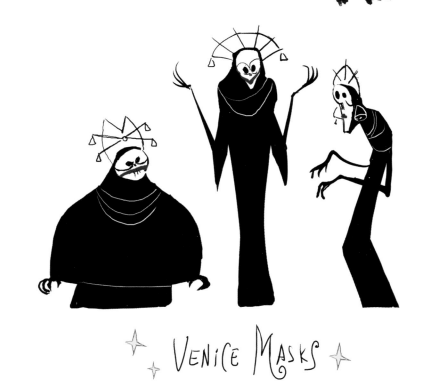

VENICE MASKS

THE THIRD EYE

Masks open up so many possibilities. Next, I explore the idea of adding a third eye. Here, the mask only covers the forehead and eyes. I love Slavic culture so I add specific hat designs and the color red that are prominent in Slavic design. I also think of this group of witches as like the Fates from Greek mythology – that's why they have a single eye and the thread of fate in their hands. These witches are less abstract than the previous group – they look more tragic and creepy.

YOU LOOK FAMILIAR

Next, I want to explore the cliché that witches have familiars – animal companions that serve the witch. It can by any animal, but is traditionally a raven, frog, cat, or snake. I think adding animal features to the witches themselves will give them a unique look. Adding human traits to animals can also be effective – if you need to design five frogs of the same type, giving each a different human personality will differentiate them.

Opposite page (top):
I research masks from different cultures

Opposite page (bottom): Witches wearing masks and draped in cloth, inspired by the Venice carnival

This page (top): Witches with a Slavic-influenced mask design

This page (bottom): Choosing familiars for my witches

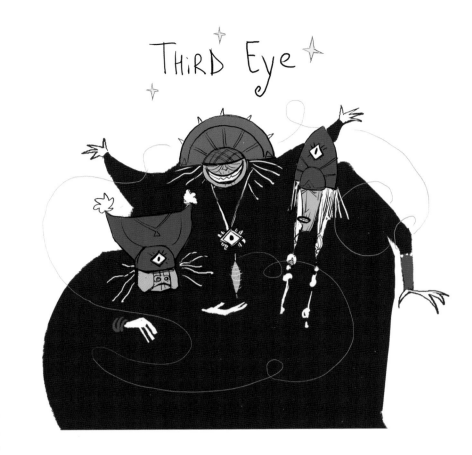

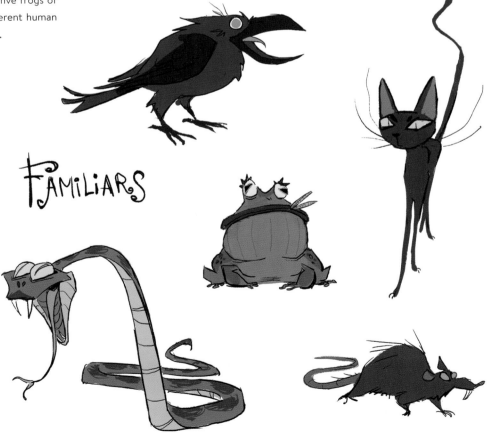

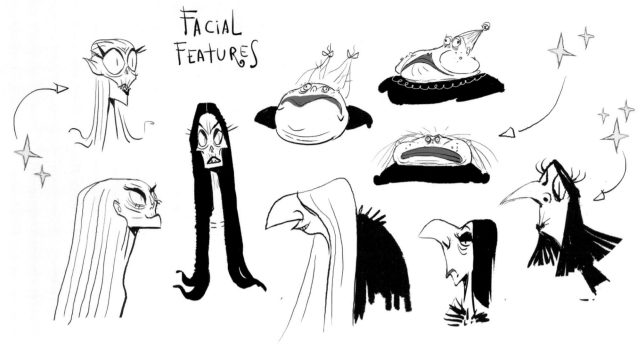

FACIAL FEATURES

ANIMAL INSTINCTS

I play with adding animalistic features to my witches' designs. I start by playing with the faces, as this will always be the focal point of a character. I pick snake, frog, and raven for my prototype, combining them with my earlier face designs that I think will fit. Once I have chosen my faces, I do a full body check to see how they work together. I want this group of witches to be funny and creepy at the same time – that's why I twist their faces into a more cartoon style. These characters have nice shape contrast and different personalities – they look good enough for final development.

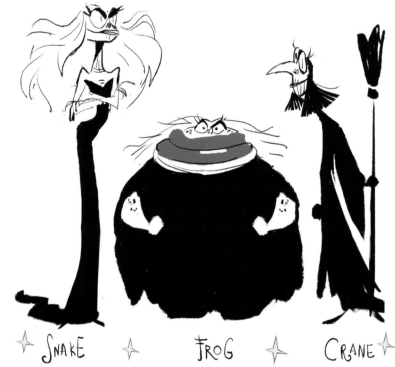

SNAKE FROG CRANE

HANDS HAVE PERSONALITY, TOO!

Sometimes, artists give all their attention to a character's face and costume and forget that hands are an important design element as well. Hands can tell us a lot about a character. Elegant characters may have long, thin fingers, while creepy characters have bony fingers and long sharp nails. Every element of a character helps you speak to the audience and say what you're trying to say.

WITCH CRAFTS

I want to give my group of witches something interesting to do in my final design, so I research what props they could use. It's possible to do this step much earlier in the process and include ideas in your early sketches. For this piece, I wanted my sketches to look clean and simple, so I decided to look at props later. This is a great tip for beginners – don't try to solve every problem at once. Work on your character design and then worry about other items and the setting later in the process.

Opposite page: I add animal features to my witch designs

This page: Witches have all sorts of interesting props

"WORK ON YOUR CHARACTER DESIGN AND THEN WORRY ABOUT OTHER ITEMS AND THE SETTING LATER IN THE PROCESS"

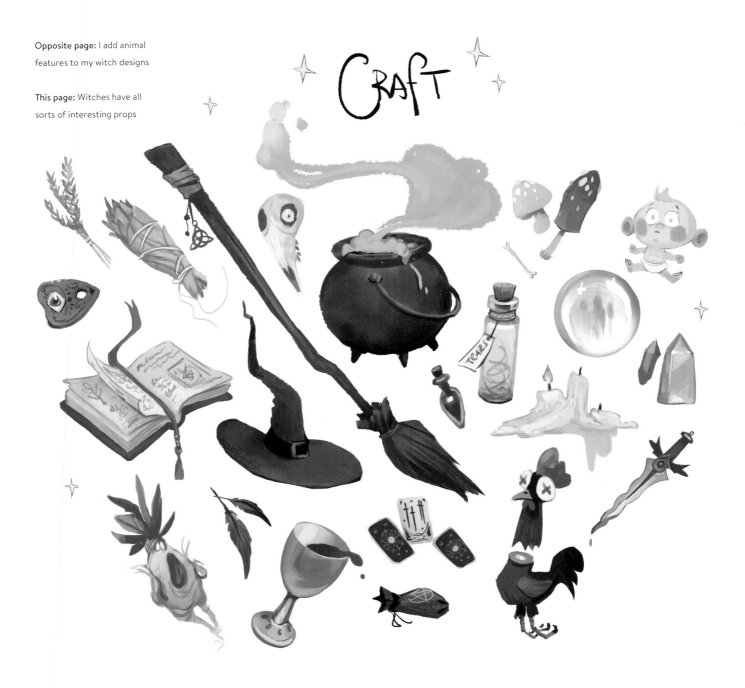

THE WITCHING HOUR

I use another cliché for my story setting: three witches cooking with a cauldron. I add a twist to the traditional design by moving the pot from the ground, to make the witches look more mobile and as though they are actively performing magic. I break the symmetry of the composition by adding flying bats and a black cat. Adding mist to the surroundings makes the image more visually interesting and creates the illusion of depth. I broke from cliché by choosing a fun bubblegum pink for the coloring, rather than the traditional green, to give the witches a more playful feel.

A VALUABLE LESSON

When working on color, a large part of your design's success will be down to value structure. Be sure you have the highest contrast in the focal points of your image – for me, this area is around the faces and cauldron. This is why the bones on the floor look more subdued. I choose fun skin colors for my witches to reflect their animal sides. It's really important that you only color and polish your character when the main idea is readable, and everything is clear. Don't rush too fast into finalizing your design – it's better to pay more attention to the previous steps so you're sure you won't be wasting your time.

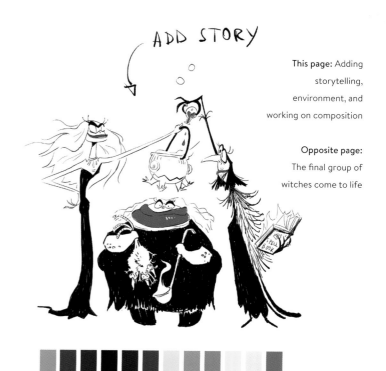

ADD STORY

This page: Adding storytelling, environment, and working on composition

Opposite page: The final group of witches come to life

COLOR SCHEME

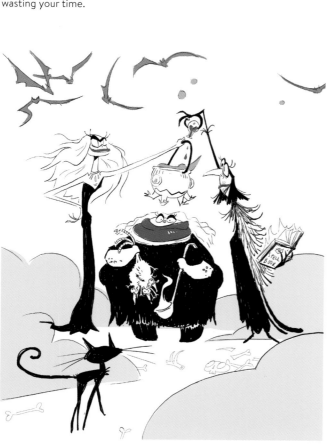

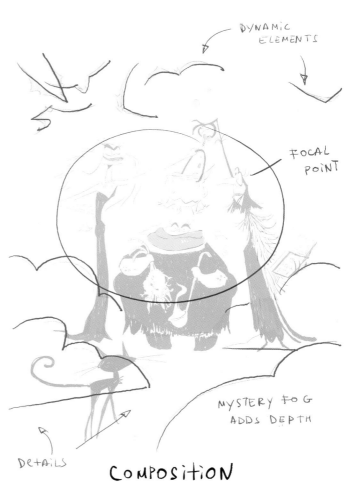

DYNAMIC ELEMENTS

FOCAL POINT

MYSTERY FOG ADDS DEPTH

DETAILS

COMPOSITION

"SINCE EACH PROJECT HAS A DISTINCTIVE LOOK, IT IS VERY IMPORTANT TO BE CONSISTENT WITH THE DIRECTOR'S VISION"

Klaus is unique in that it's the only project where SPA dealt with every aspect of production – going forward, are you keen to work on entire projects like this?

We would like to focus our efforts on producing our own projects. Sergio Pablos' ideas are truly unique and different from each other, and we're also open to incorporating new creators into the process. Our goal for the future is to develop a slate of movies with different stages of development running at the same time, so we can maintain a solid artistic crew.

What would you say are the driving principals behind character design at SPA Studios? Are there certain rules that you follow, regardless of the project?

Since each project has a distinctive look, it is very important to be consistent with the director's vision. It helps that we have such a talented and adaptable team. We are very fortunate to work with Torsten Schrank as our Character Design Lead – his team is always pushing the boundaries artistically. Making these ideas work for the animators is always a key challenge for the character design department.

STAFF SPOTLIGHT: TORSTEN SCHRANK

Job title
Lead Character Designer

Education
I studied Animation at Konrad Wolf Film University of Potsdam-Babelsberg, Germany.

What are the best bits about working at The SPA Studios?
Defining the personality of a character through drawing is still a fascinating experience for me. That moment of finding the right scribble that has attitude, appeal, and style is mesmerizing. I enjoy giving the director as many options as possible for each character – eventually we find that one special drawing that nails what we're looking for.

And what do you consider the biggest challenges?
The biggest challenges might be to combine artistic preferences with the needs of a 2D hand-drawn feature film production. Each character will be drawn by many different artists throughout the production; therefore the design of the characters shouldn't be too complicated to draw, but also not be too generic. I call this "manageable uniqueness."

What advice would you give to budding character designers?
Take every opportunity that comes your way, even though it might not be your "dream" project. Knowledge about the principles of animation and acting will elevate your character design skills. Don't try to draw just one style — be versatile and push yourself outside of your comfort zone. Stay hungry, curious, and humble.

"WE WANT TO MAINTAIN A CULTURE WHERE WE NURTURE EVERYONE AND MAKE SURE WE ENABLE THEM TO GROW PROFESSIONALLY TO THEIR FULL POTENTIAL"

This page: Design suggestions for Stuul from *Smallfoot*

Opposite page:
Attitude poses of Migo

As the size of productions grow and the number of employees increases, is it important to you to keep the culture of the workplace the same?

Absolutely! We grew from a medium-size boutique studio to a full production with over 300 people in-house in just a few months – we want to maintain a culture where we nurture everyone, and make sure we enable them to grow professionally to their full potential. It may require extra effort in the early stages of building a studio, but it will be totally worth it in the long run.

How would you describe the animation industry and culture in Spain?

It is ever-growing and there is an increased interest in traditional animation, which is what we focus on. We are lucky enough to work with

and count on great international professionals, but also have a large amount of Spanish talent working in our studio.

How has the pandemic affected life at SPA Studios? As we start edging back toward normality, have you found there are lessons learned from the past three years that will be useful going forward?

We were lucky enough to not have our project affected, since we were in the early stages of development. However, we had to change the way we worked and adapt to the new situation almost overnight, just like everyone else. Communication and coordination among the teams has been key to a successful outcome. Redesigning the way we work without compromising quality and commitment to the project was our top priority. We are continuing to build upon this new way of working and always aim for a better environment for everyone.

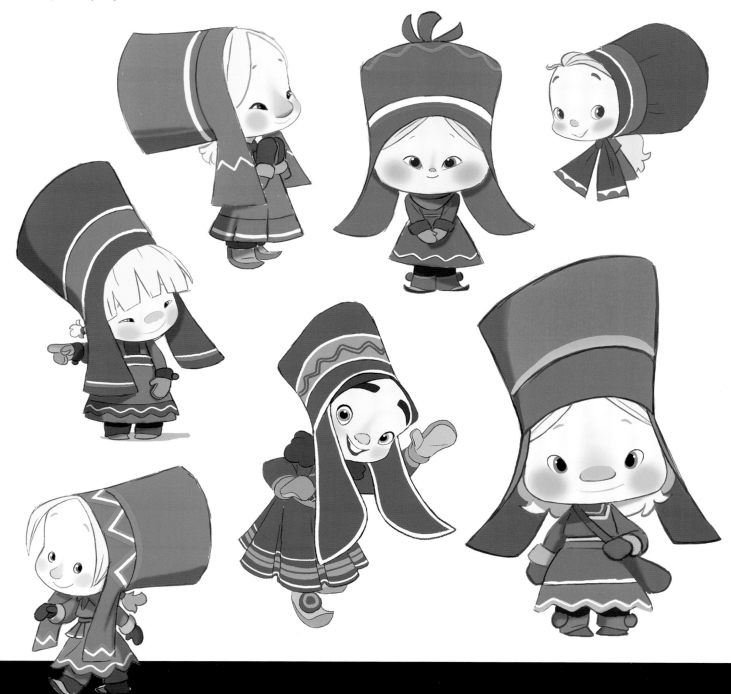

There's a whole host of great tutorial videos on YouTube created by SPA Studios. How important is it to you to help artists discover the processes at work behind large animation projects?

Incredibly important. Our objectives on social media are to educate, inspire, and entertain — that's why we have been creating behind-the-scenes features, tutorials, breakdowns, and much more. Hopefully, they are useful to those who watch them. From the feedback we have been

And finally, SPA Studios is a place a lot of our readers would love to work – what advice do you have for artists looking to be hired at a company like yours?

The SPA Studios is continually working on improving itself, project after project. For this to be possible, we are always on the lookout for the talent that best fits our philosophy. In addition to having a portfolio that is representative of their skill, artists need to show a genuine passion for 2D animation, and be open to being continually challenged. We want

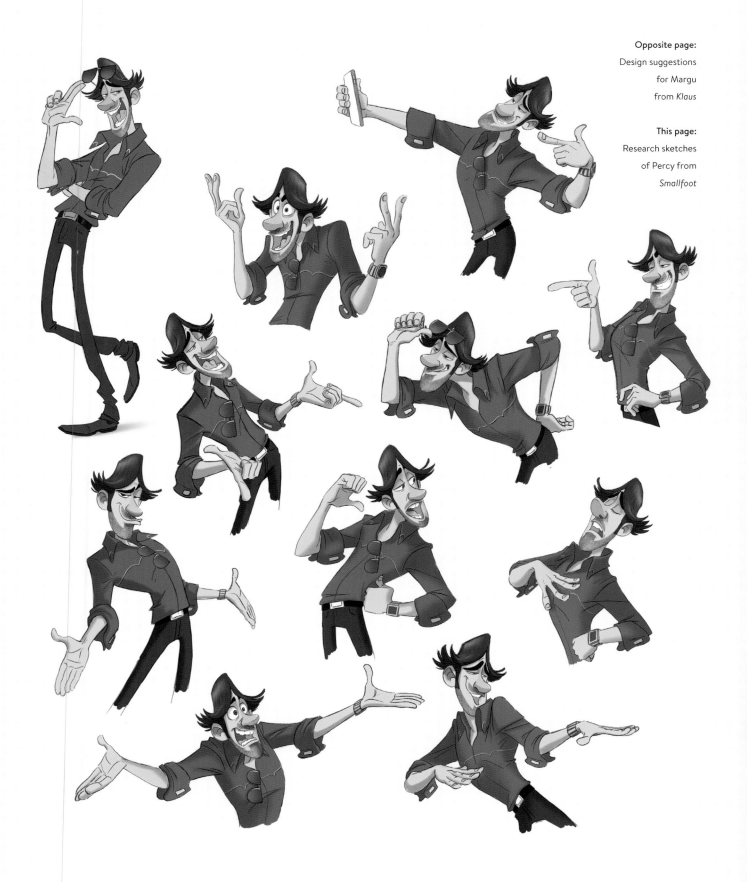

Opposite page:
Design suggestions
for Margu
from *Klaus*

This page:
Research sketches
of Percy from
Smallfoot

CHARACTERIZE THIS:
BOTANICAL BELLBOY
LISANNE KOETEEUW

When I was asked to design a character around this brief, I realized there were lots of ways to approach the assignment. I thought about what I like to see myself in these kinds of articles: walkthroughs, a little peek into an artist's kitchen, and some specific pointers about brushes, techniques, and layers. I'm going to take you through my process, starting from the brief and showing you how I build up a sketch, line work, and colors. I'll tell you a bit about my brushes and show you how to apply textures to give your illustration a vintage feeling.

WORD CLOUDS

My process is very intuitive. I find gathering references, making a word cloud, and drawing small doodles around the brief are good exercises to start. Through this process, I'll often find interesting things that spark a thought. For this project, I find a bug shaped like a thorn which gives me an idea for a possible direction for the character.

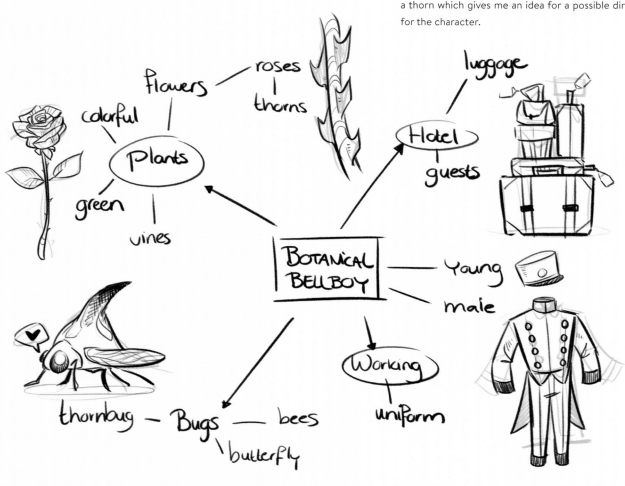

EASTERN
TIGER
SWALLOWTAIL
CATERPILLAR

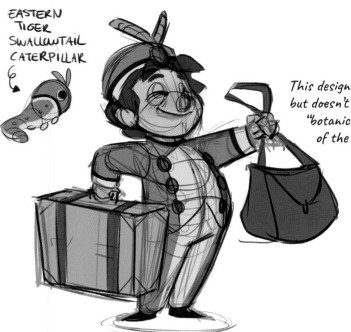

This design is cute, but doesn't fulfill the "botanical" part of the brief

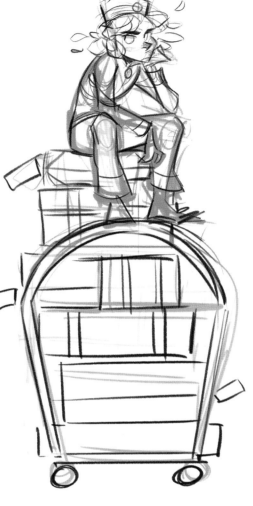

This thumbnail feels too human, and I realize I want the character to have a happier vibe

I mock up the same character to see if adding color helps convey "plant" better, but he still feels too human. I do like the face and leaves for hair, so I will develop this thumbnail further

THUMBING THROUGH IDEAS

When sketching thumbnails, keep it loose and relatively simple. Try not to worry too much about making a beautiful or "correct" drawing – you're just generating ideas. Apply some color when you're ready and try to feel out which thumbnails work and which don't – and don't forget to ask yourself *why* this is the case.

SKETCHING
THE SILHOUETTE

At this stage, the sketch is very rough and loose. This step is mostly about placement, finding a general flow for the character and a silhouette that I'm happy with. I decide to give my character a mass of thorny vines for legs that he could use to lift people's heavy suitcases. I also want to incorporate insects, so I add some thorn bugs for animal companions. I imagine they help him collect tips!

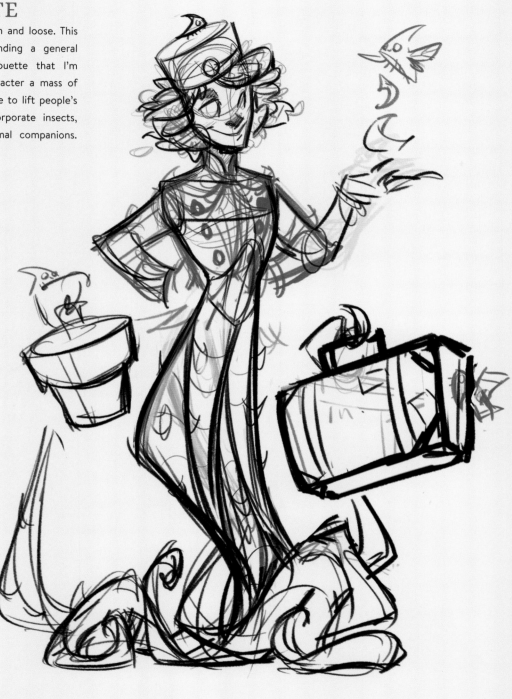

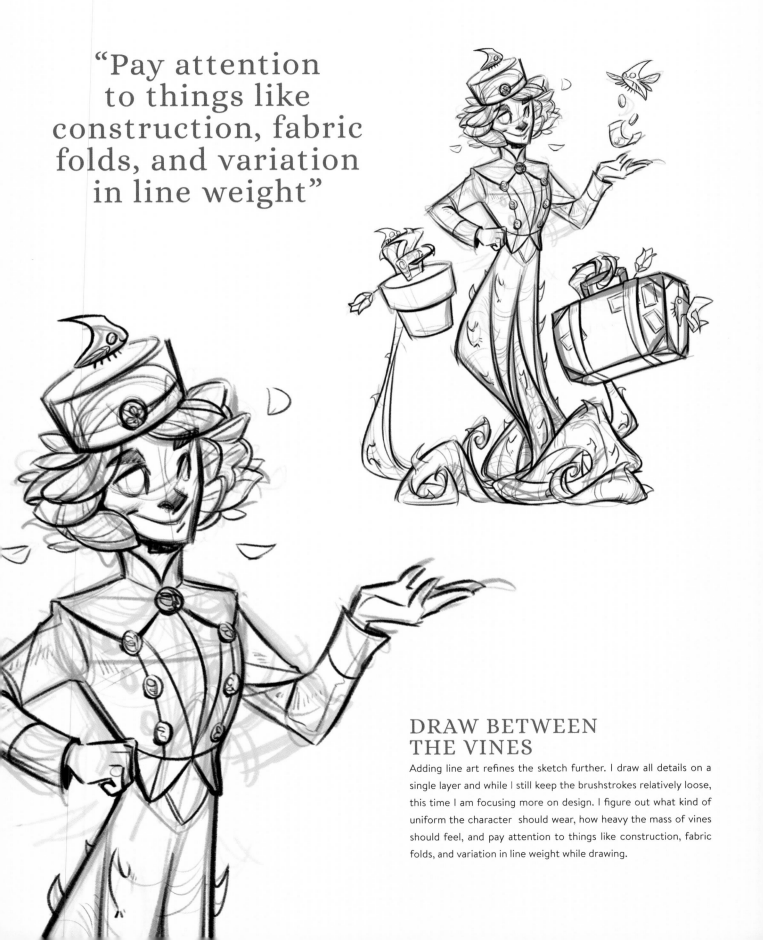

"Pay attention to things like construction, fabric folds, and variation in line weight"

DRAW BETWEEN THE VINES

Adding line art refines the sketch further. I draw all details on a single layer and while I still keep the brushstrokes relatively loose, this time I am focusing more on design. I figure out what kind of uniform the character should wear, how heavy the mass of vines should feel, and pay attention to things like construction, fabric folds, and variation in line weight while drawing.

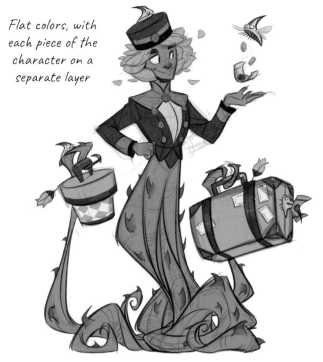

Flat colors, with each piece of the character on a separate layer

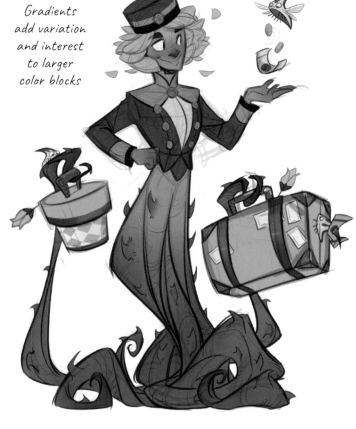

Gradients add variation and interest to larger color blocks

THE COLOR CONUNDRUM

The earlier mock-up helps me determine roughly where I'd like my colors to go, so I start laying down flat colors on separate layers. This allows me to manipulate the values of each separate piece to get the result I want. I also set my sketch and ink layers to Multiply and color them to match the flats.

PRESERVING LIFE

Many artists struggle with preserving the "life" of a sketch when they move to the inking stage. For me, the solution was to incorporate the sketch in to my line work. I quite like it when my lines aren't crisp and clean, but instead retain the messiness of the sketch. By keeping your sketch and inks on separate layers you can still manipulate them individually and have either be as prominent as you like.

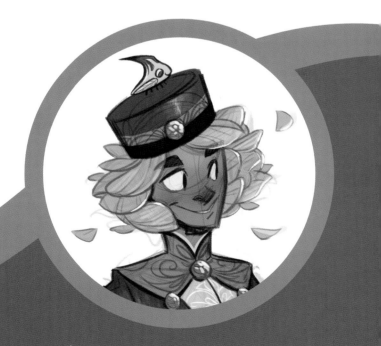

Add textures where needed to differentiate materials, such as the fabric jacket and hat

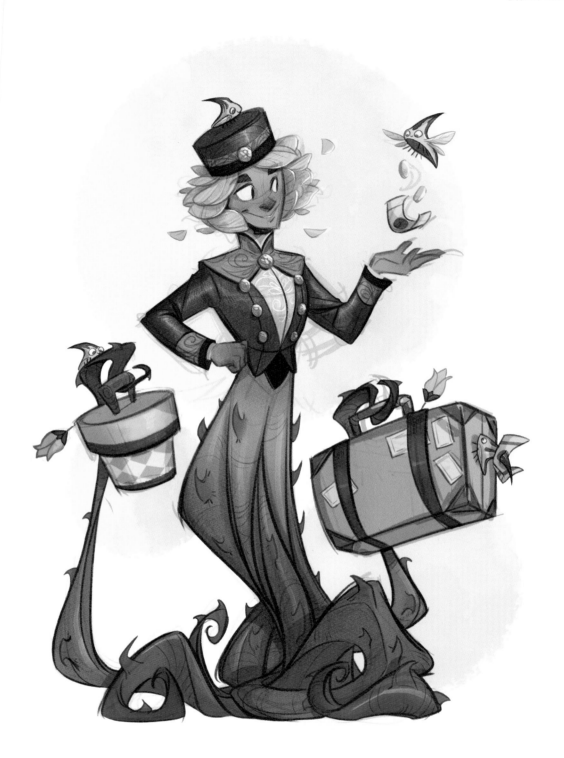

TEXTURES AND LAYER MODES

Using color and texture overlays early allows you to change the whole vibe of your image in an instant. For a more vintage feeling I use a muted orange on an Overlay layer and a canvas texture layer on Hard Light. I also add a gray layer that I set to Overlay and use a Noise treatment for some extra texture. Experiment with the sliders to see how different combinations and percentages of layer modes will change the feeling of your illustration.

THE HOTEL IS OPEN!

To finish, I give the character a simple shadow and light pass with Multiply and Overlay layers, respectively. I also want the image to have a more faded, vintage feeling, like an old yellowed postcard, so I use a number of texture layers to achieve this effect. To complete the drawing I add a simple background that won't distract from the character.

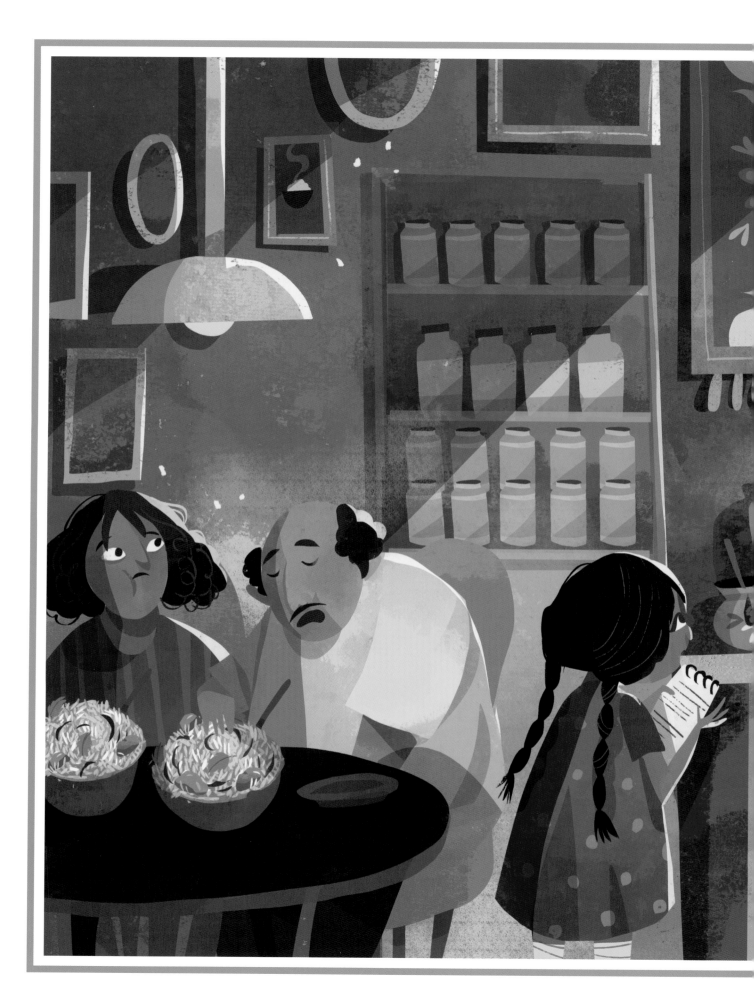

These pages: Spread from *Anni Dreams of Biryani*, published by Amazon Publishing (Two Lions) in 2022, written by Namita Moolani Mehra

MEET THE ARTIST:
CHAAYA PRABHAT

Chaaya Prabhat is a graphic designer, illustrator, and lettering artist, based in India. Her unique, intricate designs have a brightly colored and friendly look that has led to Chaaya's illustrations being featured in countless children's books. We caught up with Chaaya to chat about how her distinctive style came to be, her career so far, and how important color is in her work.

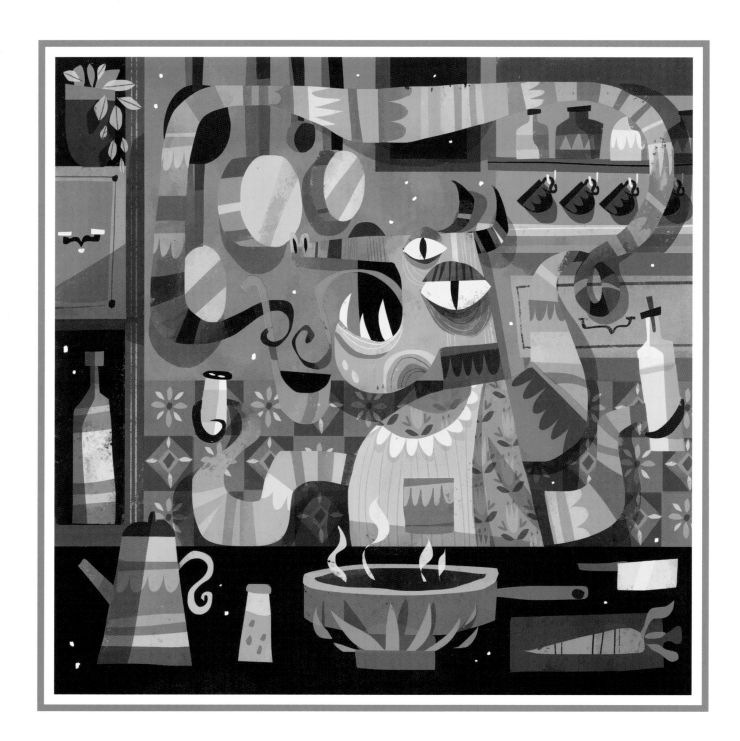

Hi Chaaya, welcome back to *CDQ*! Could you start by giving our readers an overview of your career so far?

Thanks for the welcome! So far, I've been lucky enough to work on a number of children's books for various publications, including *Anni Dreams of Biryani* (Amazon Publishing), *A Taste of Honey* (Storey Publishing), *The Best Diwali Ever* (Scholastic), *Hide-and-seek History:* *The Greeks* (Little Tiger Publishing), and *Big Cats (A Day in the Life)* (Macmillan). I've also had the opportunity to work on some really cool sticker projects for Facebook, as well as a Diwali gift card for Target. I've also been working on several book covers!

This page: A creature attempting to cook

Opposite page: Personal illustration of an old Tamil folktale

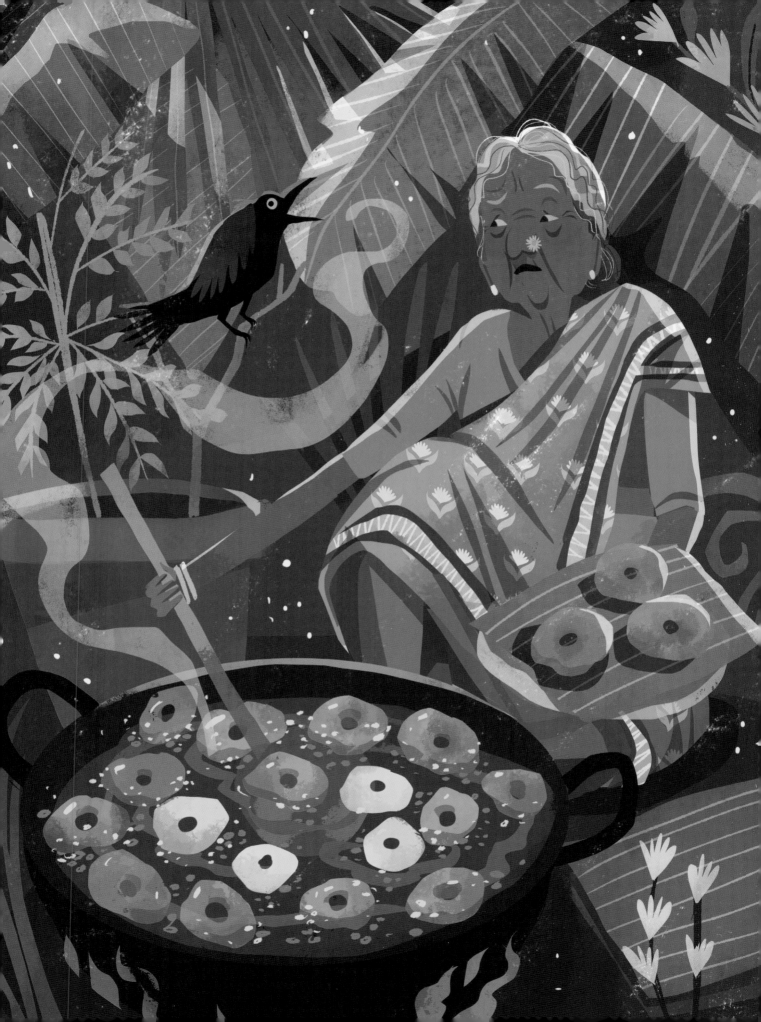

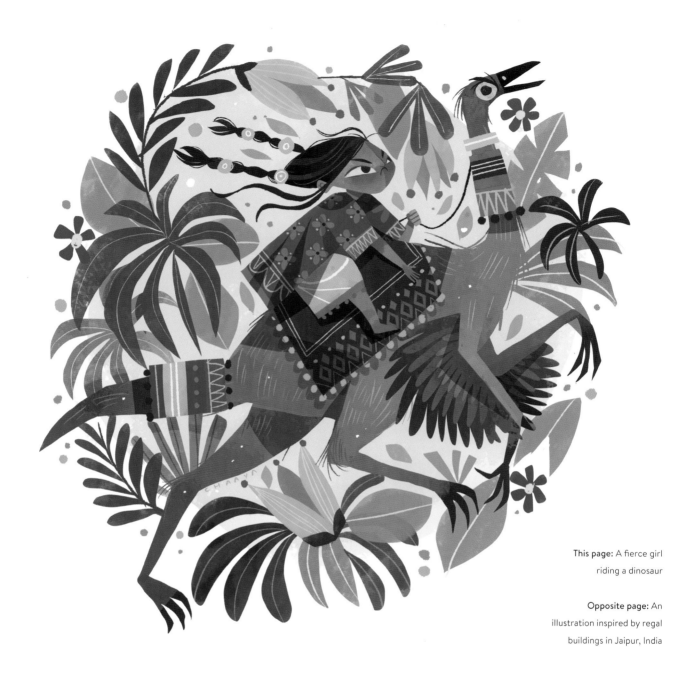

This page: A fierce girl riding a dinosaur

Opposite page: An illustration inspired by regal buildings in Jaipur, India

What was your path into the industry, and do you have any tips for getting started working on children's books?

I've only ever been good at drawing, so I think I always knew I'd end up doing something related to art. In 2017, I decided to go freelance full-time and since then I've had the chance to be a part of the thriving children's book industry. For anyone who is looking to get into the industry, I recommend reading a lot of children's books and then try to create one of your own, even just as a portfolio piece. Share it on social media and it may get noticed and lead to some real work!

Your art is wonderfully diverse, but each image is recognizably yours. How long did it take to form such a cohesive and unique style?

Thank you! It definitely took me quite a few years to find my "style." In fact, I'm actually not sure if I've fully found it yet. With each year it changes a little bit and with every new project I find myself veering in a slightly different direction with style. I still need to wear different "style" hats for different commercial projects, depending on what the brief is, while also trying to remain true to how I like to draw.

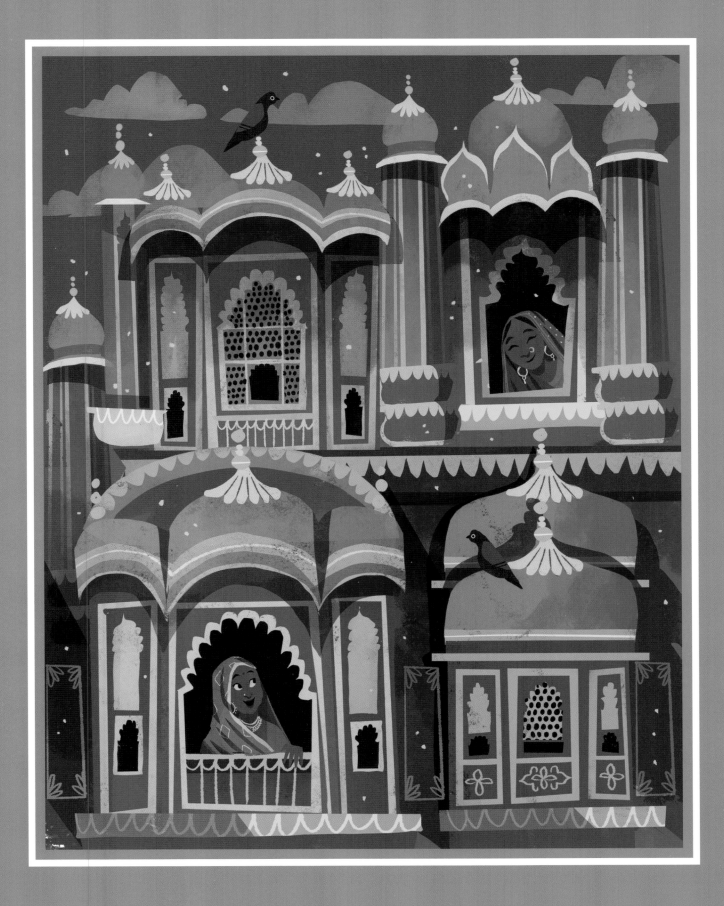

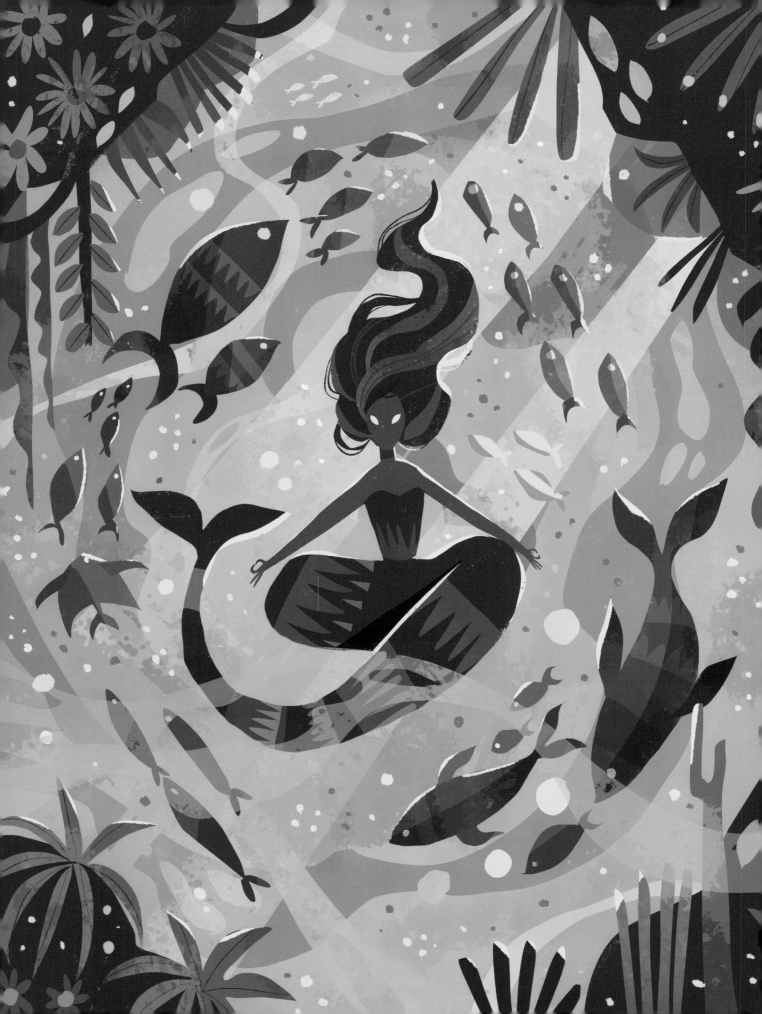

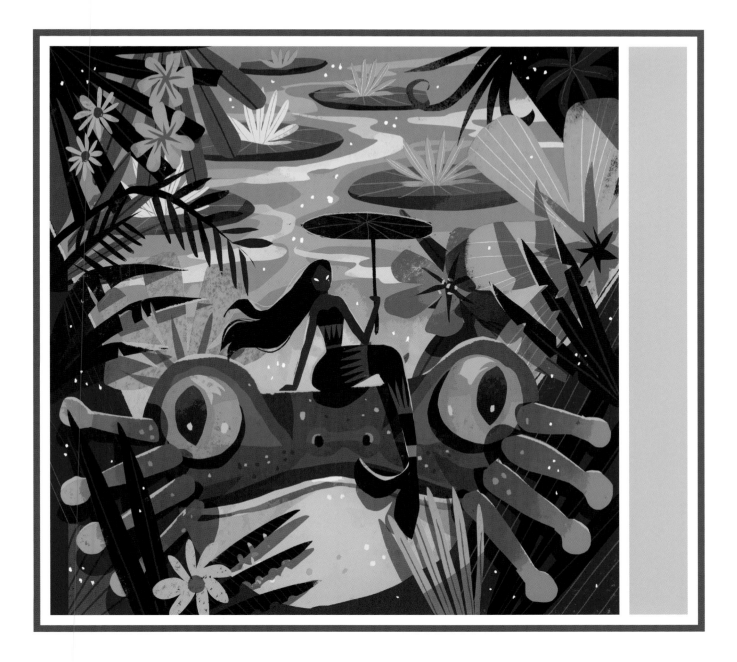

What do you consider the most important element of character design and bringing characters to life?

Since I mostly work on children's books, I always try to look at my characters through the eyes of the children who'd potentially be reading it and try and think of things they would notice.

The other striking thing about your art is your control of color. What's your process for deciding on what color palette to use?

Color is something I find really exciting – it's my favorite part of every project. Usually, I start picking colors based on the brief - for example, if the mood of the illustration is "happy," I try thinking of happy colors and then go from there. I like to play around with color palettes by shrinking my sketch down to

a thumbnail size and then trying various colors together to see how they match and make the illustration look overall.

Opposite page: A mermaid meditating underwater

This page: Whimsical illustration of a mermaid riding a giant frog

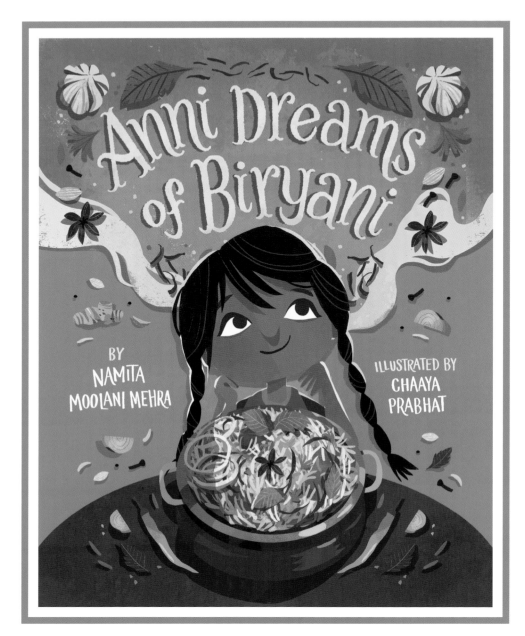

This page: Cover from *Anni Dreams of Biryani*, published by Amazon Publishing (Two Lions) in 2022, written by Namita Moolani Mehra

Opposite page: An illustration inspired by the narrow alleyways of Goa, India

Do you have any tips for conveying emotion through relatively simple character designs?

I think this is something I'm still learning, and I've found that using my own face as a reference is great. Whenever I feel like a character isn't emoting well I try taking a picture of myself making the same face or feeling the same way the character is, and I then use that as a reference.

What project are you most proud of, and why?

It's hard to single out a project, but my current favorite is my most recent project, *Anni Dreams of Biryani* – a picture book written by Namita Moolani Mehra and published by Amazon Publishing. It's about a girl who really loves biryani and cooking. I got to play around with a lot of incredible food-based compositions while illustrating the book, which was so much fun.

Finally, are there any projects we should be looking out for from you that are coming soon?

I have a few children's books coming out later in 2023 that haven't been announced yet, as well as some super interesting digital projects that I can't wait to share soon!

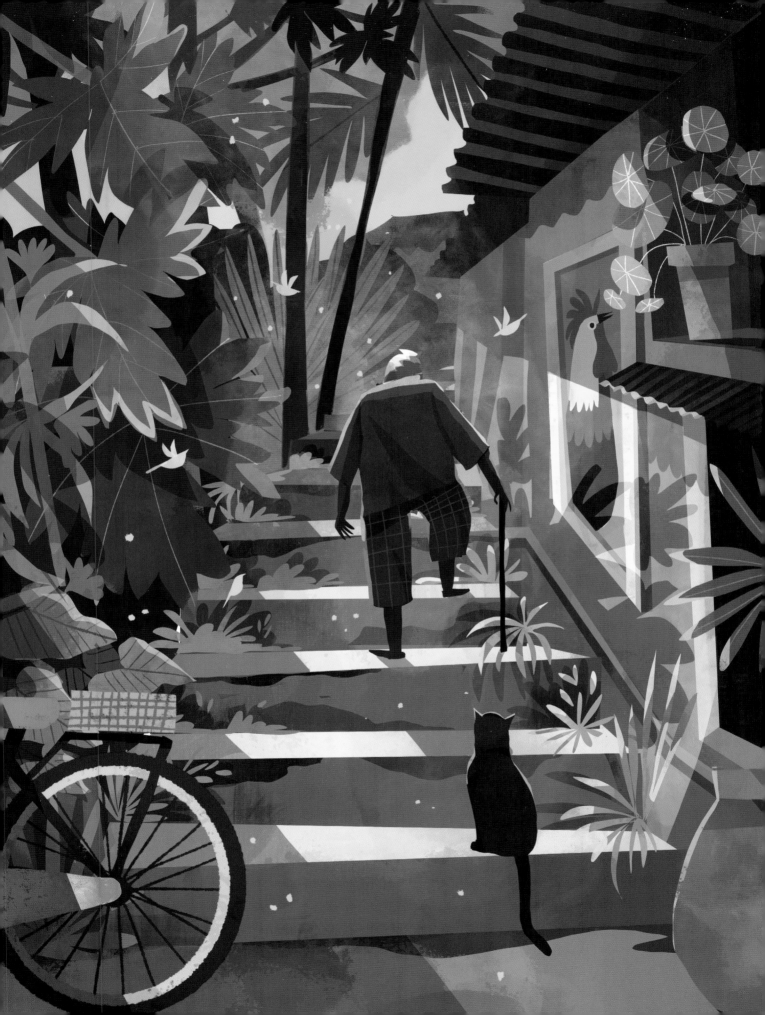

RELEASE YOUR INNER CHILD

LEA EMBELI

On these pages, I'll share my best tips and advice on creating a character that appeals to children. You can use these tips when creating a character for a children's book, animation, or anything else aimed at a younger audience. Use the materials you enjoy the most – I mostly draw in Procreate, but I also love working with paper and watercolors.

BUILD A MENTAL LIBRARY

I start by warming up and collecting references from real life. Observe and memorize interesting people and objects – all sorts of things can go toward making a fun design. If you keep a loose reference in mind throughout the process, your character will definitely be more appealing, convincing, and fun.

SHAPE SHIFTING

A character aimed at children should be easily recognizable and have an interesting silhouette. Try thinking about how different shapes relate to certain characteristics and personalities. Don't be afraid to combine different shapes to push your characters further.

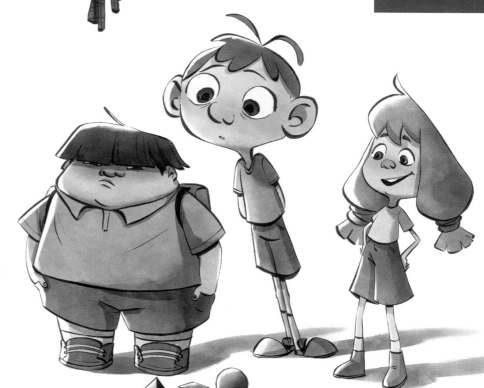

TWEAKS AND CHANGES

If you find yourself stuck while drawing your character, try making little changes to the design and proportions. You will be surprised at how moving the facial features a few millimeters can change the look and feel of a character.

MAKE FRIENDS WITH YOUR CHARACTER

Think about your character's emotions, likes, dislikes, special quirks, and personality traits. Getting to really know your character will naturally bring a lot of interesting details to the design. The more detail, the easier children will relate to the character and want to get to know them.

All images © Lea Embeli

"DRAWING YOUR CHARACTER IN DIFFERENT POSITIONS AND EXPRESSIONS WILL HELP YOU UNDERSTAND THEM BETTER"

EXPRESSIONS AND MOVEMENT

After you are happy with your character, try moving them and bringing life to the design. Drawing your character in different positions and expressions will help you understand them better and, in turn, make them seem more convincing and believable.

MIX YOUR MEDIA

Explore different ways of rendering your design. If you've only used digital media try a bit of watercolor or experiment with simpler styles – don't be afraid to try something new. Different techniques can help you create new interesting styles that will be more approachable and appealing for children.

DON'T FORGET TO HAVE FUN!

Try to have fun with your design and don't take it too seriously. Experiment a lot and make as many sketches as necessary. There are no mistakes and every drawing you make will only help you improve.

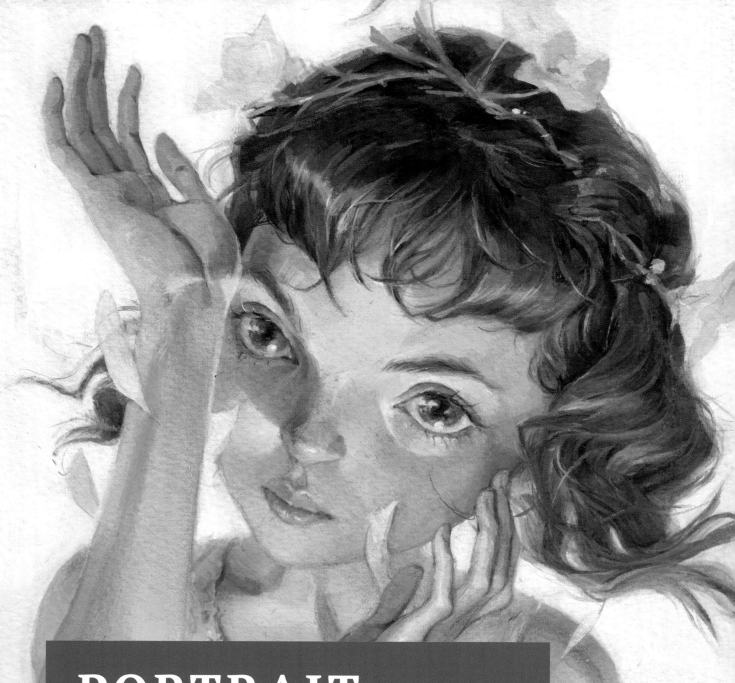

PORTRAIT MASTERCLASS
FATEMEH HAGHNEJAD

In this tutorial I'm going to share with you all the steps I take to create a character portrait using watercolors. The core idea for this piece is a young girl, surrounded by magical lights to create a fairy-tale feel. I'll work through the whole process, from capturing the first rough ideas, through to using acrylic gouache and digital tools to achieve the results that I am looking for in the final artwork.

SMALL BEGINNINGS

First of all, I need to get to know the young girl I'm going to draw. I find it very useful to decide on one clear idea before putting pen to paper. I like to think that my character is real and she is breathing somewhere in this universe. To focus, I listen to music that suits my character while I am planning and then, once I've established the important ideas, I switch to audiobooks. I also start to write down all the words that come to mind for this portrait painting, such as magic, wonder, dust, innocence, warmth, and joy.

CREATING THUMBNAILS

Creating thumbnail sketches of my ideas helps clarify the path I'm on and will allow me to approach the later steps of the design with speed and confidence. I try out as many different ideas as possible, different angles and facial options, looking for the values and shapes that will tell the story in the best way. It's important to decide which perspective and composition I like and want to go forward with, while avoiding adding too much detail to keep the shapes clear.

This page (top):
I highlight the important
keywords for the
character before
I begin drawing

This page (bottom):
Capturing different
ideas with thumbnails

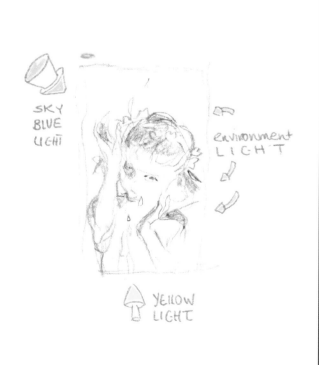

REFERENCING PROPORTIONS

Now that I have the thumbnail sketches, I choose the one I like most and take note of what I need to study. I research images of girls around nine years old, using Google to find reference images. I want to understand the face proportions in different girls around this age. While studying the pictures, I also think more about my chosen perspective. This step might feel time consuming, but it will help you to feel confident about moving forward and helps the rest of the process be fast and efficient.

LIGHT THE WAY

Lighting plays a huge part in a painting – telling the story behind the subject – so it's a great idea to spend a decent amount of time considering how it will work. I love to stylize my characters, but it's important for me to make them feel believable as well. Even if I am asked by my editor to keep the background blank, I still have to imagine where my character is so that I understand what lighting and reflections to consider.

I like to define lights with arrows to show the type and color of the light, and the direction they come from. Using my chosen thumbnail, I decide my character will be in daylight and also in shade. I want to show a smooth transition from the blue sky light to the warm light under her face.

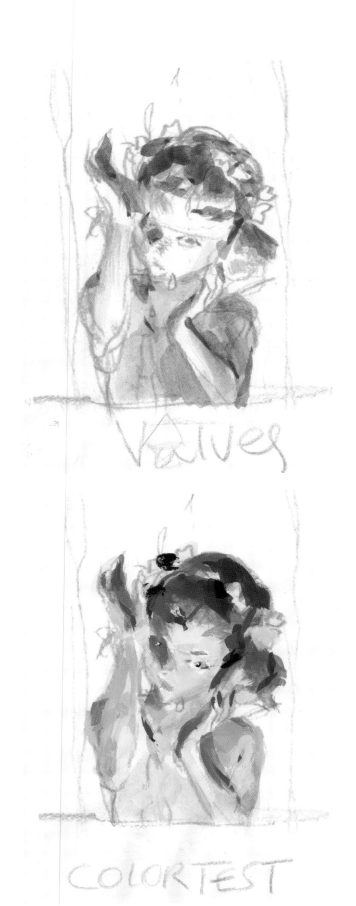

"VALUE AND COLOR TESTS BOTH MAKE THE LATER STEPS OF THE PROCESS MUCH EASIER"

TESTING, TESTING

Value and color tests will make later steps in the process much easier. With the value test I create the illusion of depth, planning broadly where the darkest and lightest sections of the drawing will be. To keep my character's face fairy-like I keep the values on her skin very close to white. I will refer back to this value test throughout the rest of the process.

Testing a few colors is a quick way to decide on a palette that will help my character shine. I play with colors, considering the environment my character is in. For example, how will the white of her dress be influenced by the colors around her?

Opposite page (top): Find references and study elements you don't feel confident drawing

Opposite page (bottom): Define your light sources and make sure you know where they are coming from

This page: Value and color tests speed up the rest of the drawing

"THESE LINES ARE SIMILAR TO THE WIRE SKELETON THAT UNDERPINS A SCULPTURE"

WORKING WITH WIRES

Finally, it's time to start drawing my character. I feel confident moving into this step of the process as I've planned ahead for the challenging parts of the design. First, I focus on the face structure and how I want to build it. I draw my characters close to the traditional proportions for their age, but I make their eyes bigger and further apart.

I start by drawing a ball and cross to get a sense of the direction the head is facing and where to place the features. The horizontal line is where the eyebrows are and the vertical line denotes the middle of the face. For the hands, I usually start by drawing simple lines and build from there. These lines are similar to the wire skeleton that underpins a sculpture.

FIXING THE FEATURES

Next, I start to place the features on my character's face. I use the lines I drew previously to help construct my character in three dimensions. I try to think about the entirety of her head, not just the angle I'm drawing. I place the eyebrows along the same line as the top of the ears and the nose aligned with the bottom. I draw the hands following the lines I placed previously, thinking about the curve and shape of each finger. It helps to look at and touch your own fingers while you draw, feeling the bones and muscles and how they move.

It takes me an hour or so to place the fingers exactly as I want them. I've found that working slowly and thinking about every action is the most pleasant way for me to draw – and after I'm done I always enjoy the finished piece more.

Opposite page: Draw a cross to get a
sense of the direction the head is facing

This page: Placing the features
and defining face proportions

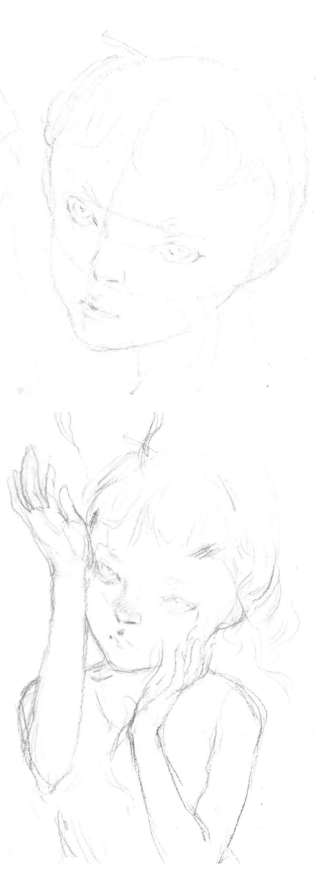

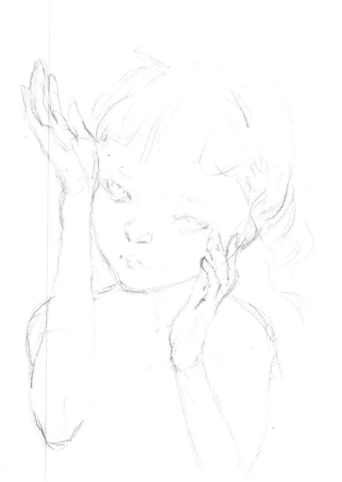

A GUST OF INSPIRATION

I work on a more defined drawing, adding details to my character, focusing on the overall shapes of the various elements. I imagine there is a wind blowing and consider how the gust will affect my character. For example, I draw her hair wild and raised into the air. I add an arrow to the sketch to remind myself of the direction the breeze is coming from.

I complete the drawing with more lines and added detail. I make the eyes stand out by adding definition to their shape, and the eyebrows, too. I draw white flowers in my character's hair and petals in the air – they will amplify the sense of movement and add a little touch of magic to the final design. Finally, I add shadows (using my value test as a guide) and draw arrows for the different light sources around my character.

These pages: Adding
motion for extra drama

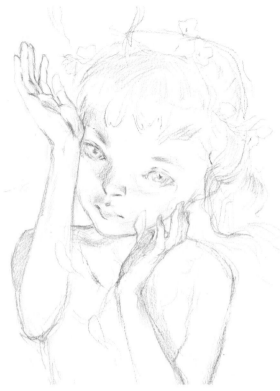

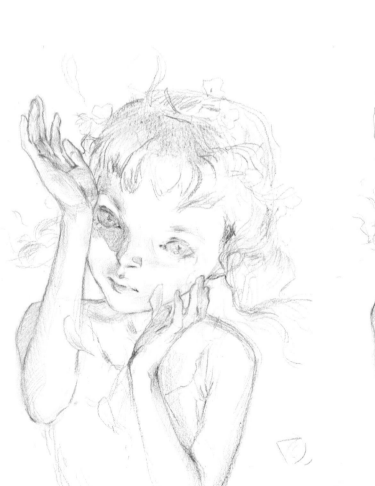

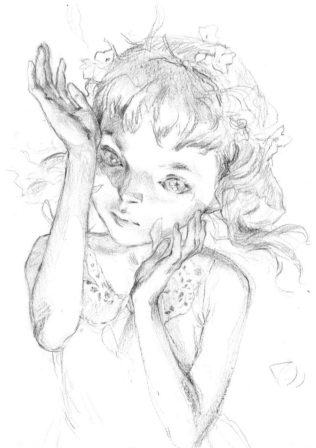

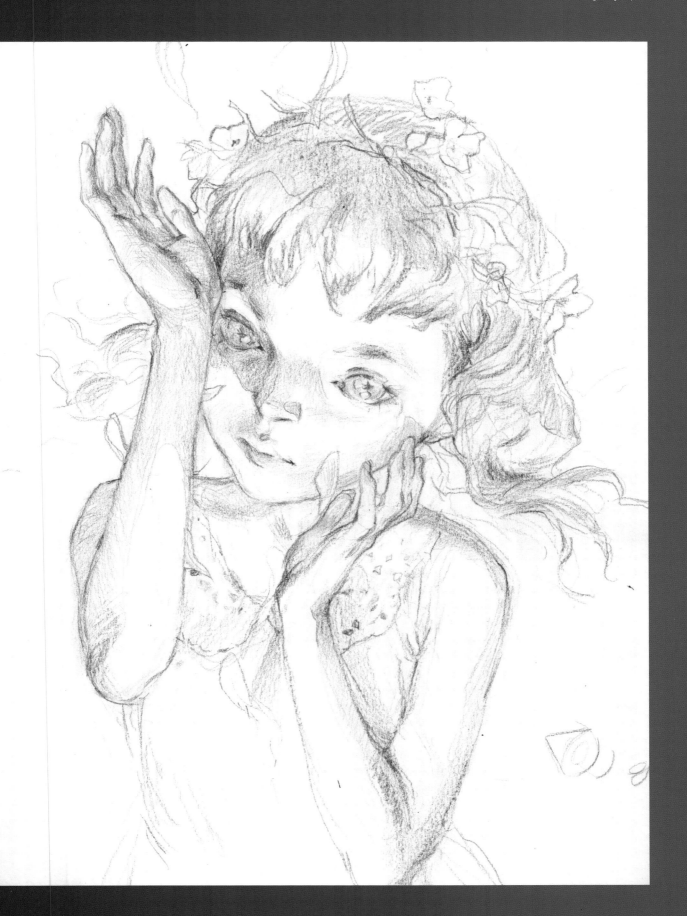

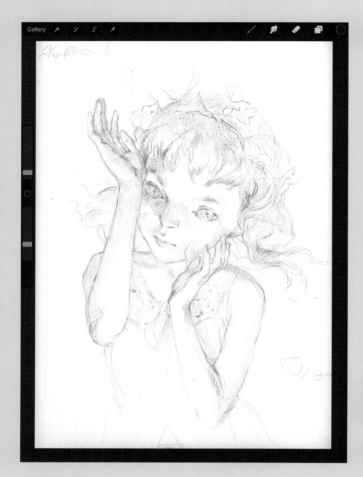

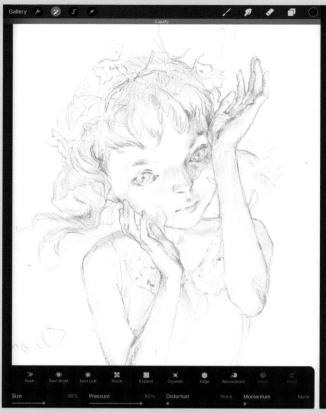

PREPARING A SKETCH FOR WATERCOLOR

Before coloring, I scan my sketch to print on watercolor paper, so I don't have to draw it again. I transfer my drawing to Procreate, flipping the canvas a few times to balance everything and fix any mistakes I see. I use the Liquify tool to push and pull the lines around, making sure everything looks right before moving on.

To prepare the sketch for printing, I use hue, saturation, and brightness Adjustment layers to change the color of my line art to red. I recommend printing the sketch on normal paper first, to make sure it's exactly where you want it to be before committing to watercolor.

If you are printing with an inkjet printer the inks are water soluable, so you will need to fix the line art with a different medium before the coloring step. I don't want to cover the texture of my paper, so I use a mix of one-third acrylic gesso and two-thirds water to add a very thin layer of wash to my paper.

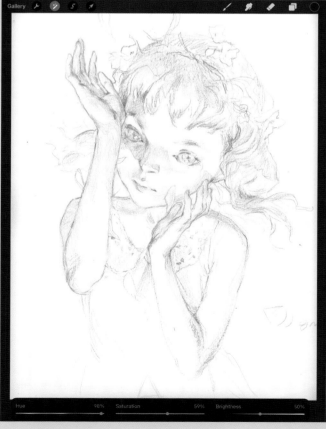

STARTING TO COLOR

Working from my earlier test as a guide, I use acrylic gouache to start coloring my character, remembering to consider how the light sources are going to affect each surface. I start from her hand and mix the blue light of the sky with her skin color. Acrylic gouache can dry quickly, so I use a wet pallet to keep my colors fresh throughout the process. If you don't have Sta-Wet palette papers you can use tracing paper on top of a damp paper towel.

MIXING PAINTS

I find it useful to take a step back from the drawing, pause, and look at my colors, making sure they're definitely what I want to use. I decide to mix some violet into my colors and add shadows to the painting. Usually, I will mix the paints I need from primary colors, but for some shades, like magenta and violet, they can look nicer straight from a fresh tube.

This page (top): I change the local colors to show they are affected by the light

This page (bottom): Understand and play with your colors

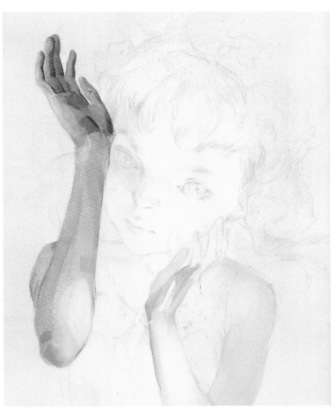

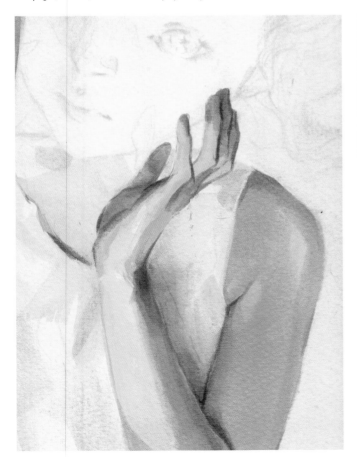

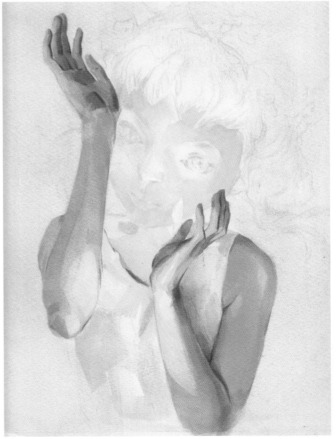

DEPTH EFFECTS

To add depth to a piece we need to pay attention to how we control the edges of our design. Sharpening edges leads the eye towards that part of the design and softening them has the opposite effect. There are many ways to blur your edges: you can smudge the wet paint with your finger, add washes of your subject's background color around your subject, or use colored pencil.

ADDING EMOTION

I want to add more emotion to the image and let the personality of my character shine through. I decide her right eye is in shadow, using darker colors than the left eye, which is affected by the warm light underneath her face. I approach the painting like I am sculpting, constantly thinking about how the ambient blue light and warm glow from below will affect the colors.

BRUSHING HAIR

For painting the hair I move the brush in the same direction as the wave of the hair. This technique lets me take advantage of the texture of the brush to create detail, without drawing individual strands. I use this technique to add light and shadow to the hair, as well. I start with thin, light washes and gradually paint darker and more opaque. I am trying to create interesting and appealing shapes, more than aiming for a realistic look.

This page (top): Control the edges to add depth

This page (bottom): Creating depth and emotion in my character's eyes

Opposite page: Follow the direction of the hair with your brush

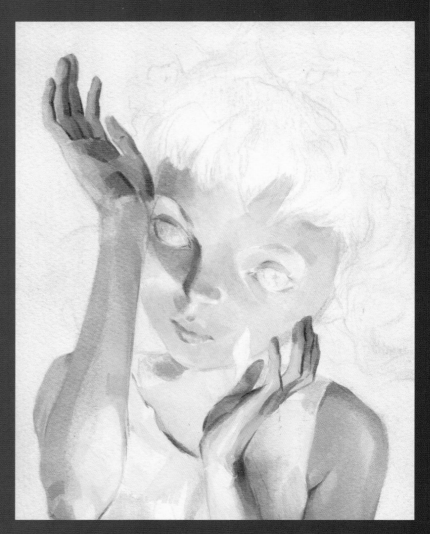

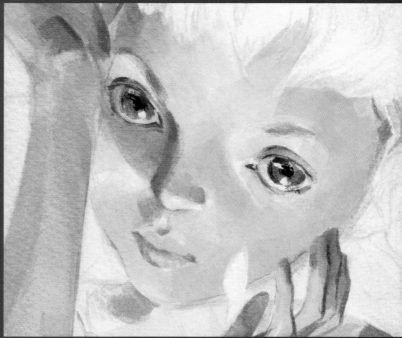

"FOR PAINTING THE HAIR I MOVE THE BRUSH IN THE SAME DIRECTION AS THE WAVE OF THE HAIR"

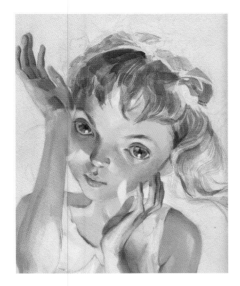

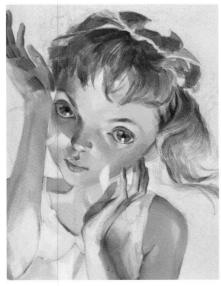

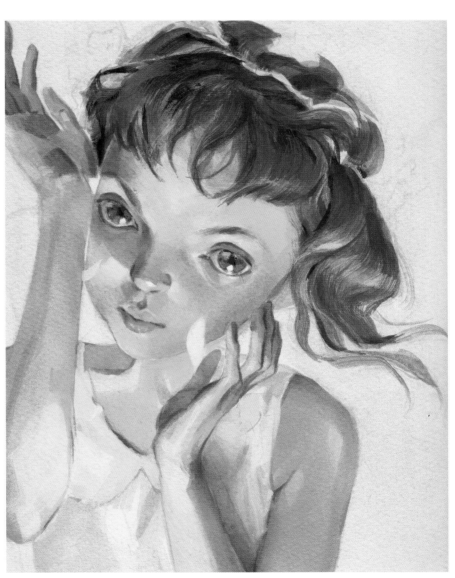

THE RIGHT TOOLS FOR THE JOB

Experiment with different techniques and mediums to find the tools that you like the most. In my experience, the materials we use really do matter. If you find yourself frustrated with your process, consider switching up what you're working with. It's always worth the effort to take the time to find whatever setup is right for you. Art should be a beloved struggle!

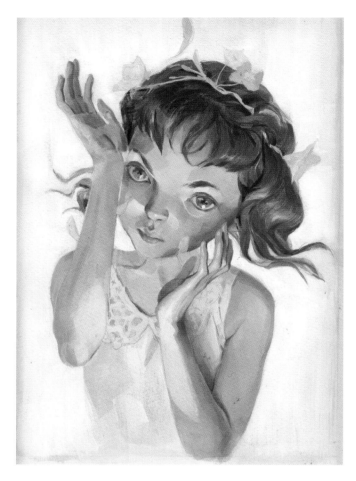
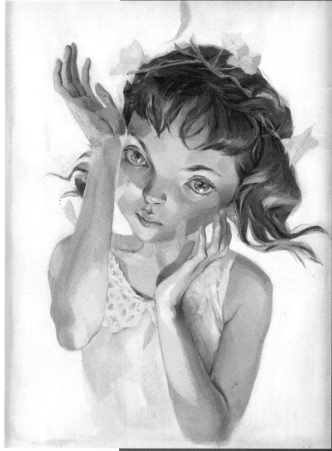

A SPARK OF LIFE

I really like the spark in my character's eyes in the drawing I made at the beginning of the process. I try to retain as much of this element of the sketch in my colored version as I can. Considering that eyes have moisture, they will reflect light more than the other surfaces of the face, so I paint the upper eyelids lighter. The different reflective surfaces and light sources will add to the glossy look for the eyes.

PICTURE PERFECT

The last thing I need to do is scan the painting and send it to Procreate to finalize the colors. I go to the Adjustment menu, choose Curves, and play around until everything looks balanced. I decide that it would be nice for her to cover more of her right shoulder, so I select the embroidery around her neck and add this to the dress. Finally, I use the Liquify tool in the Adjustment menu and move her left eye closer to the center of her face. And with that, I can happily call the portrait finished.

This page: I try to capture the feeling of
my first sketch in the final painting

Opposite page: I edit the final painting in
Procreate to add the final touches

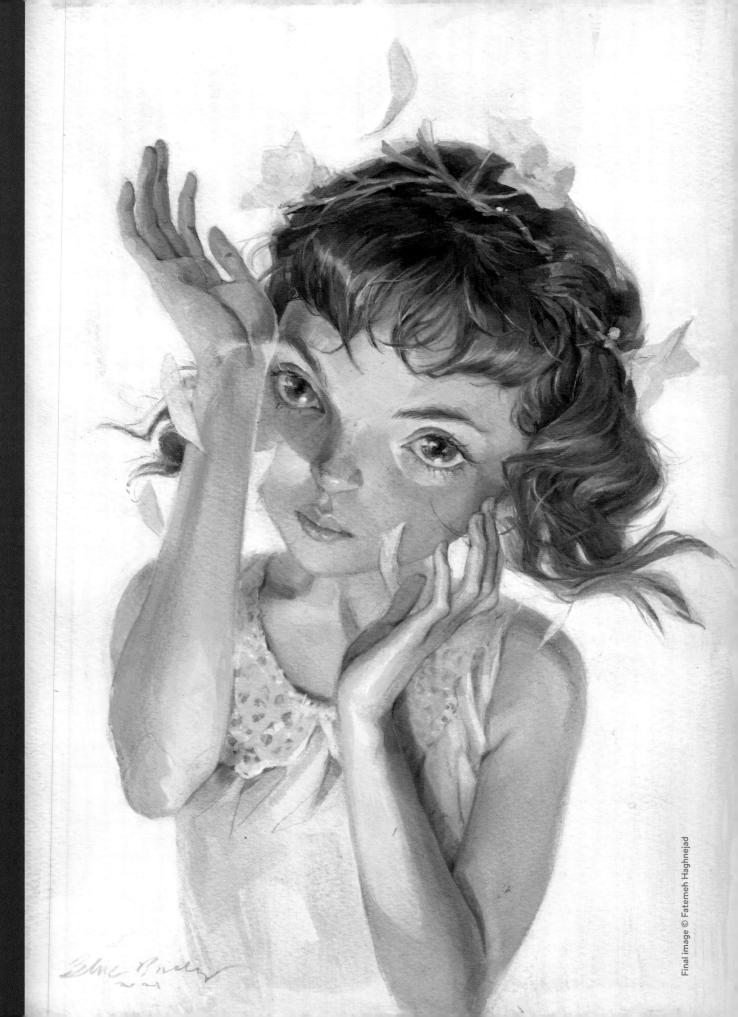

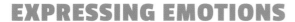

EXPRESSING EMOTIONS
SERIOUS AND SILLY
RAQUEL OCHOA

In this article we will use three different characters to learn how to express the emotions "serious" and "silly." We will focus on how to capture these two emotions using body posture, shape, and facial features.

SUAVELY SERIOUS

Low eyebrows and slightly closed eyes can help express seriousness in a character. The position of the hands indicates that the subject is contemplative, analytical, or concentrating.

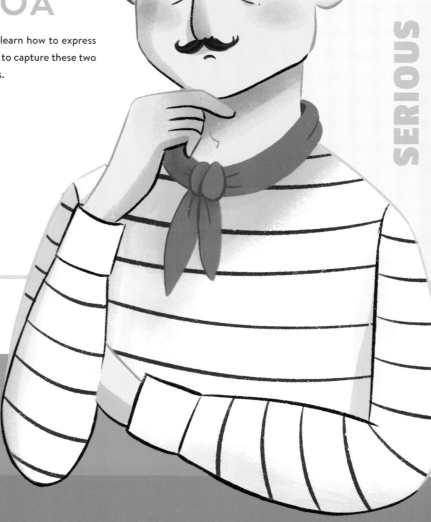

SERIOUS

"THE BEST WAY TO EXPRESS A SERIOUS OR SILLY FACE IS TO FOCUS ABOVE ALL ELSE ON THE TRIAD OF EYEBROWS, EYES, AND MOUTH"

FOOLISH FELLOW

A confused expression in a character can imply that they are not very alert, or feeling groggy. This character's eyes meeting, his raised eyebrows drawn in an inverted "V," and his mouth in an "O" shape while scratching his head, are all elements that create this sense of confusion.

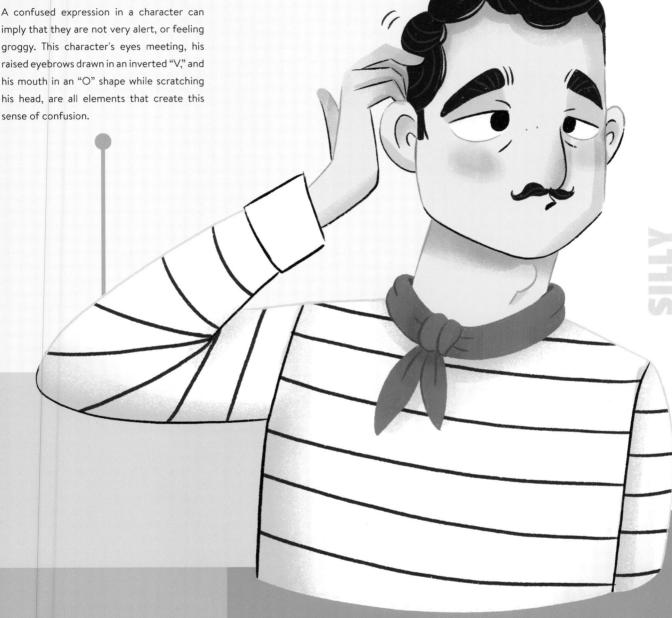

SILLY

EYEBROWS, EYES, AND MOUTH

The best way to express a serious or silly face is to focus above all else on the triad of eyebrows, eyes, and mouth. Low eyebrows and a droopy mouth will help you create serious faces, while raised and inverted "V" eyebrows can denote a silly or funny attitude. Drawing an expressive body can always help to add more information and reinforce the attitude you're after.

SERIOUS

IN A MOOD

In this image the girl has her arms crossed and her facial expression is serious. A questioningly raised eyebrow and a slightly downturned mouth express a solemn and disapproving attitude.

A PLAYFUL POSE

To show off a character's silly side, add playful expressions – I draw the girl sticking out her tongue with one eye closed, suggesting she is joking around or mocking someone. Her raised hands and tilted head convey a playful attitude.

SILLY

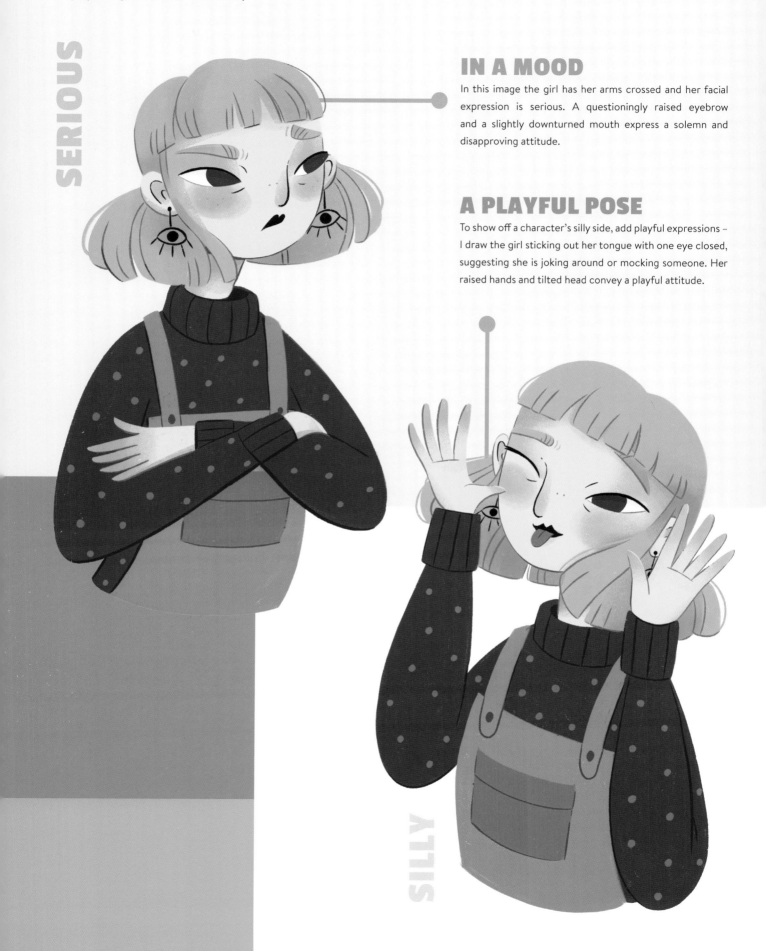

SERIOUS

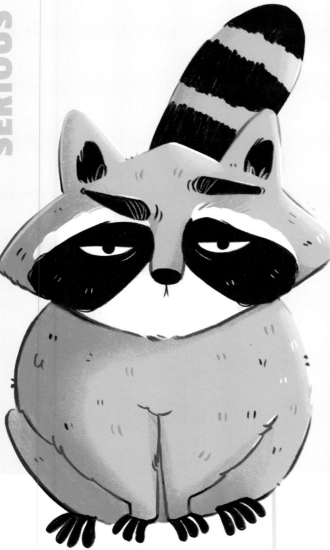

> "PAIRING STRONG FACIAL FEATURES WITH A STATIC BODY CAN IMPLY A SENSE OF DRAMA AND LACK OF EMOTION IN A CHARACTER"

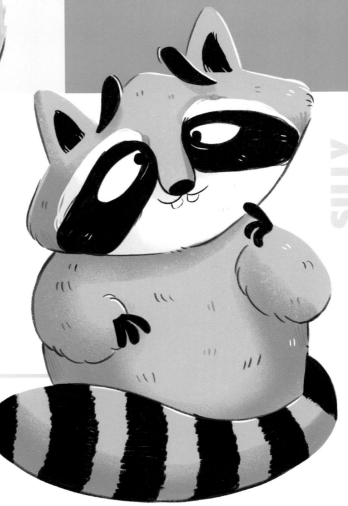

SILLY

STILL SERIOUS

Eyebrows, eyes, and mouth are your best tools for expressing seriousness in a character. Pairing strong facial features with a static body can imply a sense of drama and lack of emotion in a character.

RIDICULOUS RACOON

To create a character with a wacky attitude, try drawing a comical facial expression, with different-sized dancing eyes, or funny teeth.

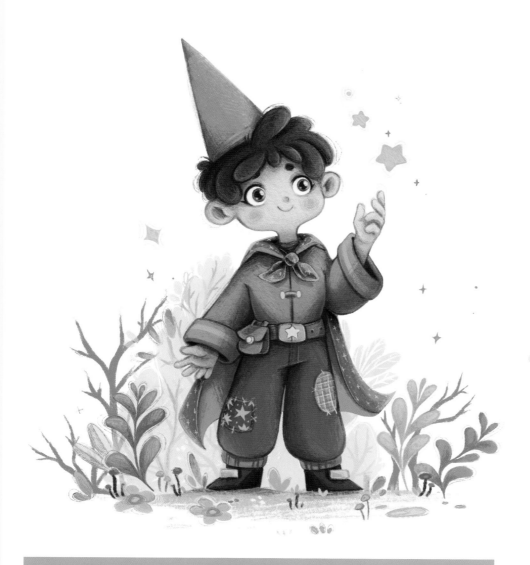

THE GALLERY

Each issue our gallery is full of fantastic art from a fresh batch of talented artists. In this issue we present work by Flor de Jager, Aleksandr Dzoni, and Arem Pak.

FLOR IS A FREELANCE CHARACTER DESIGNER AND ILLUSTRATOR FROM ARGENTINA, CURRENTLY BASED IN THE NETHERLANDS. SHE ENJOYS USING BRIGHT COLORS AND TEXTURES AND LOVES CREATING CUTE, WHIMSICAL CHARACTERS.

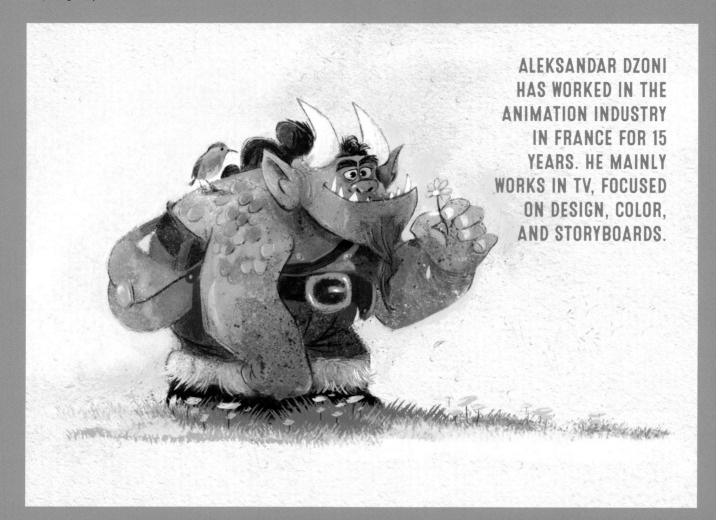

ALEKSANDAR DZONI HAS WORKED IN THE ANIMATION INDUSTRY IN FRANCE FOR 15 YEARS. HE MAINLY WORKS IN TV, FOCUSED ON DESIGN, COLOR, AND STORYBOARDS.

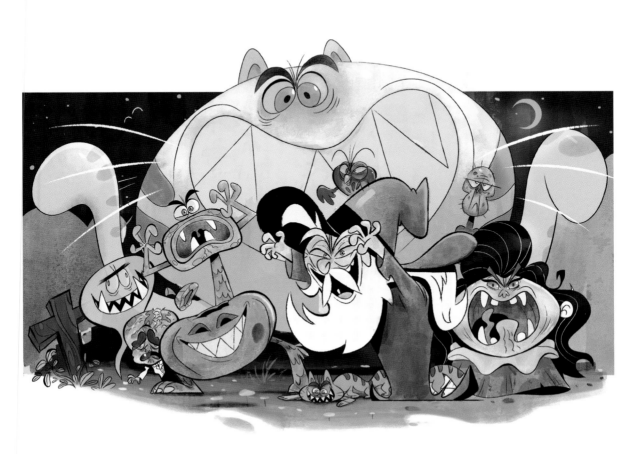

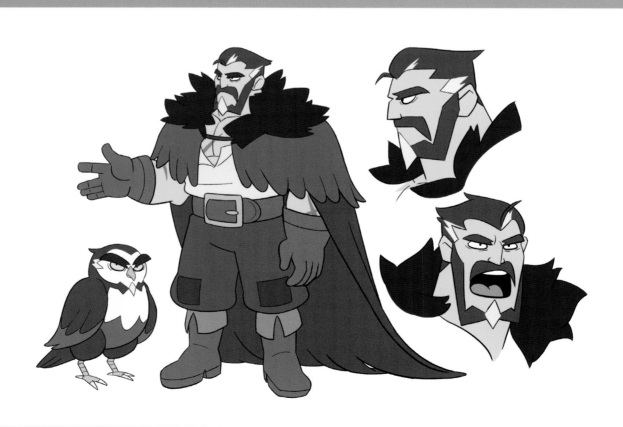

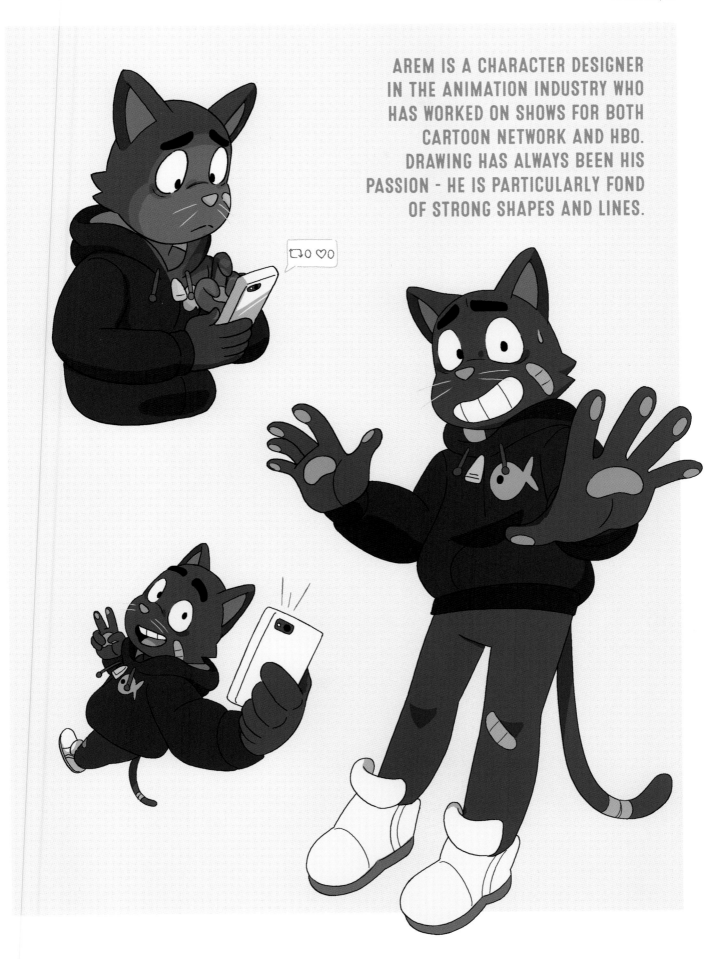

AREM IS A CHARACTER DESIGNER IN THE ANIMATION INDUSTRY WHO HAS WORKED ON SHOWS FOR BOTH CARTOON NETWORK AND HBO. DRAWING HAS ALWAYS BEEN HIS PASSION - HE IS PARTICULARLY FOND OF STRONG SHAPES AND LINES.

A KNIGHT TO REMEMBER
MARTA ANDREEVA

For this tutorial we will not only focus on how to draw a certain pose or emotion, but also explore how the personality and back-story of a character can be used to make that pose more specific and unique. Thinking about who the character is when posing them is a useful tool when making interesting and believable designs.

We will draw two characters with contrasting personalities in their "neutral" state and pose them showing the same emotions: joy and anger. We will consider each character's personality and traits to make each emotion appear unique to them.

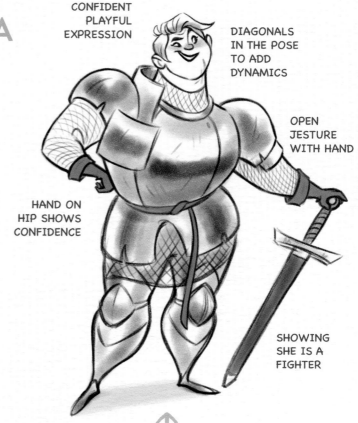

CONFIDENT PLAYFUL EXPRESSION

DIAGONALS IN THE POSE TO ADD DYNAMICS

OPEN JESTURE WITH HAND

HAND ON HIP SHOWS CONFIDENCE

SHOWING SHE IS A FIGHTER

↑

THE HEROIC KNIGHT

Our first character is a female knight who is a loud, confident extrovert with a strong, muscular build, and who also loves having fun. For her "neutral" state I draw her in an open, confident, and heroic pose.

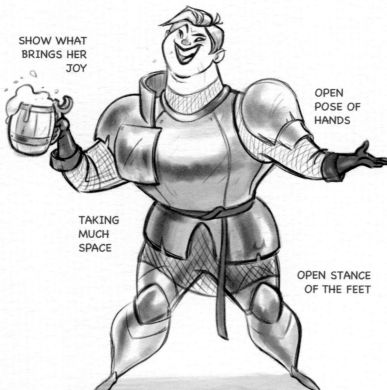

SHOW WHAT BRINGS HER JOY

OPEN POSE OF HANDS

TAKING MUCH SPACE

OPEN STANCE OF THE FEET

←

CHEERFUL CHAMPION

So, how would the knight look in a joyful state? Although she is big and strong, we want to show that she also has a great sense of humor, loves to drink, and would join in with the fun.

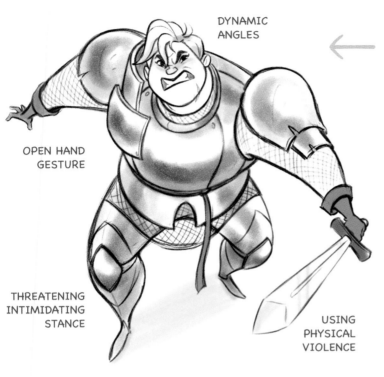

DYNAMIC ANGLES

OPEN HAND GESTURE

THREATENING INTIMIDATING STANCE

USING PHYSICAL VIOLENCE

ANGRY AND INTIMIDATING

However, when she gets angry, the knight would quickly jump to physical violence and intimidation. Again, she has a very open, confident pose and silhouette, filling the space on the page.

"THINKING ABOUT WHO THE CHARACTER IS WHEN POSING THEM IS A STRONG TOOL TO MAKING INTERESTING AND BELIEVABLE DESIGNS"

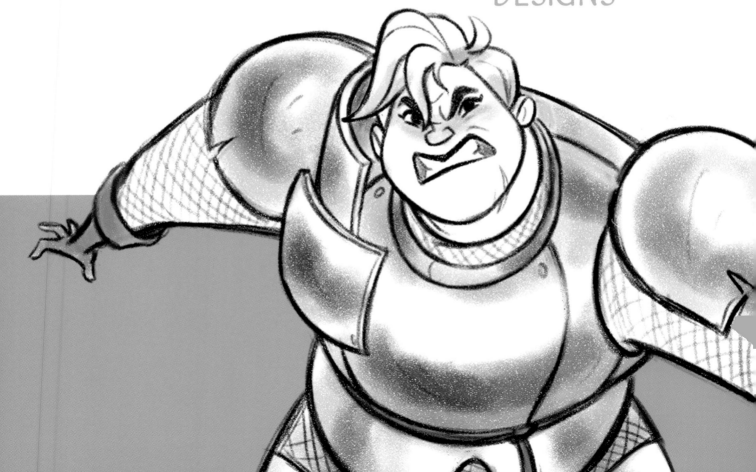

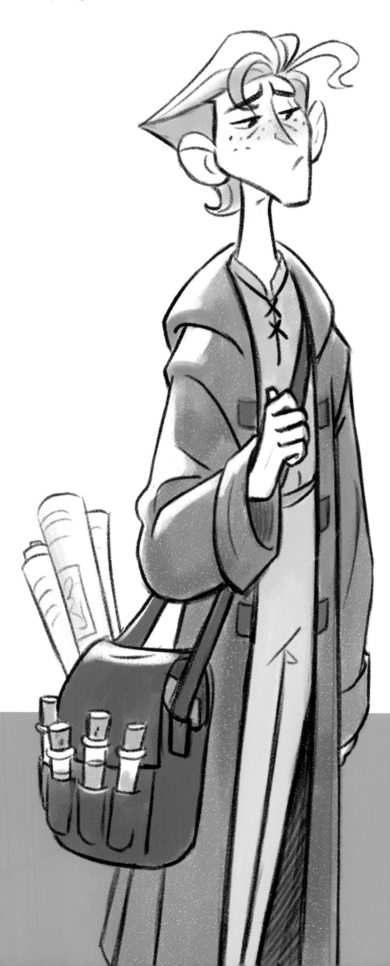

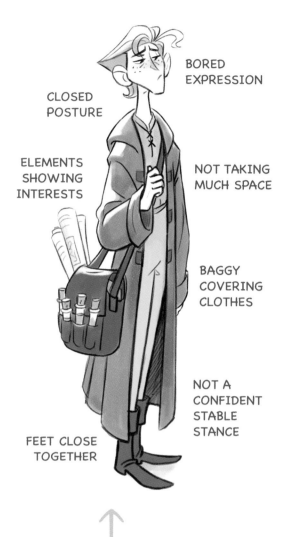

CLOSED
POSTURE

BORED
EXPRESSION

ELEMENTS
SHOWING
INTERESTS

NOT TAKING
MUCH SPACE

BAGGY
COVERING
CLOTHES

NOT A
CONFIDENT
STABLE
STANCE

FEET CLOSE
TOGETHER

THE SHY ALCHEMIST

The second character is a total contrast to the knight: a closed off, shy, and introverted alchemist, who is physically weak, but has a sharp mind.

MEDIEVAL SELFIES

It is always a great idea to act out the pose you are trying to portray and try and get into the "mind" of your character. Using a mirror or your phone to take some reference pictures helps as well, but by getting into the pose while drawing, you'll get a better feel for it. Taking this extra step always shows in the final image and makes the final pose look much more believable.

"IT IS ALWAYS A GREAT IDEA TO ACT OUT THE POSE YOU ARE TRYING TO PORTRAY AND TRY AND GET INTO THE 'MIND' OF YOUR CHARACTER"

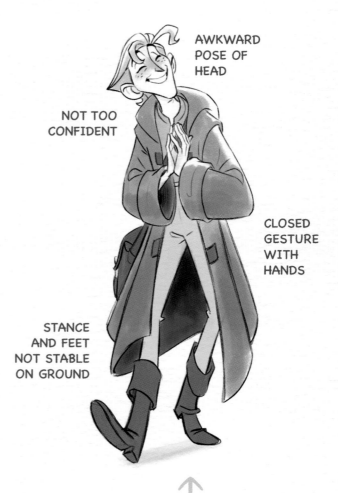

AWKWARD POSE OF HEAD

NOT TOO CONFIDENT

CLOSED GESTURE WITH HANDS

STANCE AND FEET NOT STABLE ON GROUND

AWKWARD AND AMICABLE

Our alchemist isn't used to being cheerful or joyful, so his happy pose is rather stiff, awkward, and closed off. This stance lets his introverted nature shine through, even though he is merry.

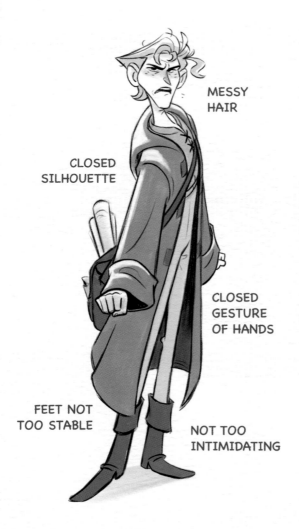

MESSY HAIR

CLOSED SILHOUETTE

CLOSED GESTURE OF HANDS

FEET NOT TOO STABLE

NOT TOO INTIMIDATING

FLUSTERED AND ANNOYED

In his angry pose, the alchemist still appears physically weak and not particularly intimidating. Again, his pose and silhouette are closed and don't take up much space.

Although our knight and alchemist are experiencing the same emotions, by thinking about their personality in how they are posed we can emphasize their differences, making them more interesting, complex, and nuanced characters.

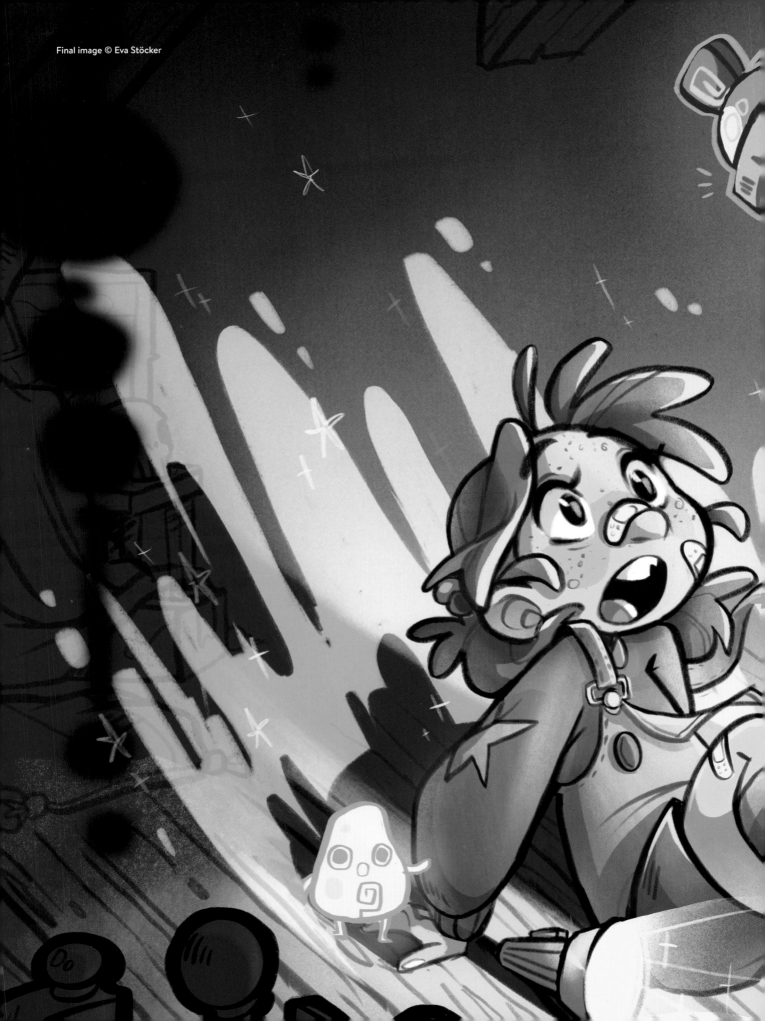

A MYSTERY IN THE MAKING

EVA STÖCKER

Creating your own character design is always an exciting journey, but the final appearance is only one part of a successful design – to truly bring your creations to life you need to consider their background story, feelings, behaviors, and especially their interactions with others. In this tutorial I'll talk you through my creative process for the realization of a character following a narrative brief. I will discuss well-known design techniques, such as shape language, composition, line of action, and color. I'll also explain how to build up a strong personality and create an eye-catching illustration that tells a story that will captivate your audience.

BRAINSTORMING

Before starting with the actual character design, we need to brainstorm! Consider what your first thoughts were when reading the brief, and ask yourself who (or what) you'd like to draw. Other important questions are where, why, and what you need to consider in regard to the intended audience. Scribble down every idea that comes to mind after reading the creative brief. I think this first step is probably the most creative part of the whole process. I always carry a sketchbook with me (and even keep one beside my bed) so I can capture every thought and idea.

MAPPING THE MIND

I collect and sort my initial thoughts around the three main elements of the brief I have been given: "A happy-go-lucky child," "mysterious artifact," and "strange powers." I start with the character itself, scribbling down some keywords and specifics about the character I'd like to create. I consider what "happy-go-lucky" means, and what words I associate with it, and then do the same for "artifact" and "powers."

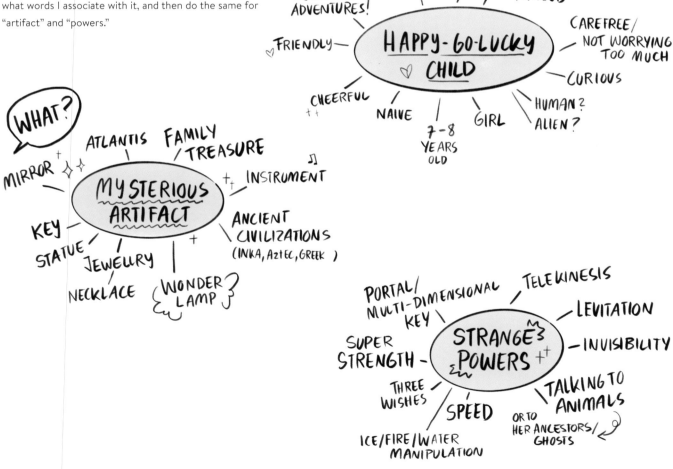

Opposite page (top): Inspiration strikes in the strangest places: in the shower, watching TV, even on the loo!

Opposite page (bottom): Mind maps can help you sort through your ideas

This page (top): Workspace and tools

This page (bottom): I wanted to expand the narrative beyond the simple brief I was given

WRITING THE NARRATIVE

With a simple brief, you are free to create a deeper narrative around your characters before the design process begins. This will make it easier to create a fully realized design later on. With a background story in my pocket, and a mind-map full of buzzwords, I start to look closer at the world I've created. I decide what aspects of the story will be the most fun to draw, what makes sense for the character, and what scene I want to compose. Now I can start to visualize.

A HAPPY-GO-LUCKY CHILD DISCOVERS
A MYSTERIOUS ARTIFACT
WITH STRANGE POWERS

A girl is visiting her grandmother during her school holidays. Bored by the slow pace of life at her granny's, she starts to explore the house. One day she ends up in the attic where she finds all the treasures her granny (once an archeologist) collected from around the world. In one corner the girl discovers a mysterious artifact with strange powers - carefully hidden by her grandmother - which will change her life forever.

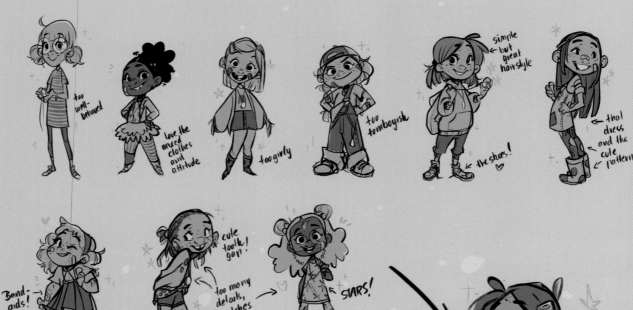

LET THE FUN BEGIN

I draw some rough character sketches based on the traditional shapes: square, triangle, and circle. Feel free to play with as many different body types as you like, but don't forget the original brief, and keep your mind-mapped buzzwords in mind. Start mixing and matching features until you settle on a design that encapsulates everything you want your character to be.

This page (top):
I thought a necklace could be the "artifact" but this idea didn't completely work

This page (middle):
Because the main audience are children you should draw rounder shapes

This page (bottom):
Exploring which hairstyle suits my character best

Opposite page:
My final design is detailed but still simple enough to be readable

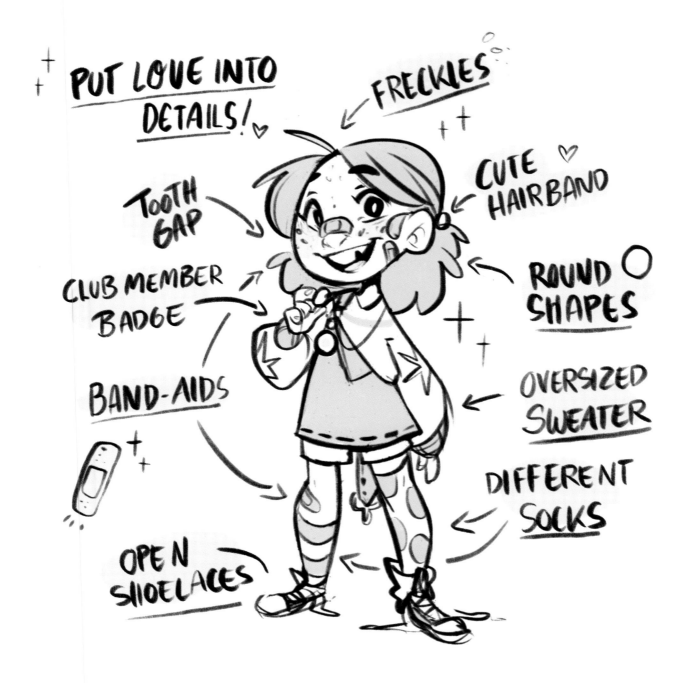

"MAKE SURE THE CHARACTER REMAINS SIMPLE, FUNCTIONAL, AND WITHOUT ANY DISTRACTIONS"

THE FINAL DESIGN

With a design chosen, I now add details to make my character more complex and believable. As you add extra elements to the design always keep in mind that less is more! Make sure the character remains simple, functional, and without any distractions.

I give my girl a cute, bright smile, and cheeky freckles to show that she's a "happy-go-lucky" child. Her funny combination of clothes show that she's not worrying about much, and has a playful outlook on life. The band-aids and gap in her teeth show that she loves adventure, has a curious mind, and loves taking risks.

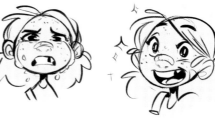

PULLING FACES

I find it helpful to explore a character's personality more by creating an expression sheet. You need to be able to fully understand your character in order to bring them to life and make them believable. I ask myself, how would my character react to certain circumstances? How would she show her emotion?

This page (top): Explore your character's emotions

This page (middle): Emotion can be expressed through the whole body, not just the face

This page (bottom): I experiment with color, looking for the perfect palette

Opposite page (top): With my young audience in mind, I use round and cute shapes for the final artifact design

A PALETTE OR TWO

Next, I explore different color palettes for my character. I choose bright, vibrant colors as they read as happy and energetic, the characteristics I want for my girl. These colors are also appealing to the young audience I'm targeting and complement the character's personality. The most iconic character designs use only four or five colors, so try to keep your palette as limited as possible. The simpler, the better!

COLORS AT A DISTANCE

If you're unsure which color scheme you should choose it can be helpful to look at your color palettes from a distance – it will be easier to recognize which have the best contrast.

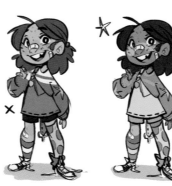
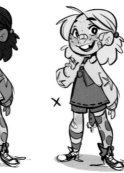
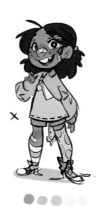

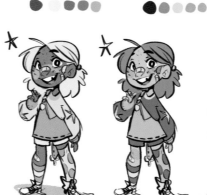
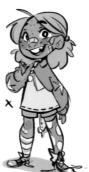

· warm & playful
· balanced
· nice contrasts

MYSTERIOUS MUSINGS

I need to work out what form the "artifact" from the brief will take. My initial thought is to create a magical lamp which my character's grandmother brought home from one of her adventures. I don't like the idea of a little girl having three powerful wishes, though, and I don't think there's much potential in the story I can tell.

I think again and decide on a multidimensional key which will open portals to other worlds! A normal key still seems a little boring, so I add a twist to the design. With children's toys in mind, I turn the key into an ancient spinning top. I try out different shapes and add runes which I found during my brainstorming phase.

FINDING THE ARTIFACT

As you can see, I changed the appearance of the artifact a lot! Don't get discouraged if your first, second, or third idea doesn't work – throwing ideas out is a normal part of the creative process.

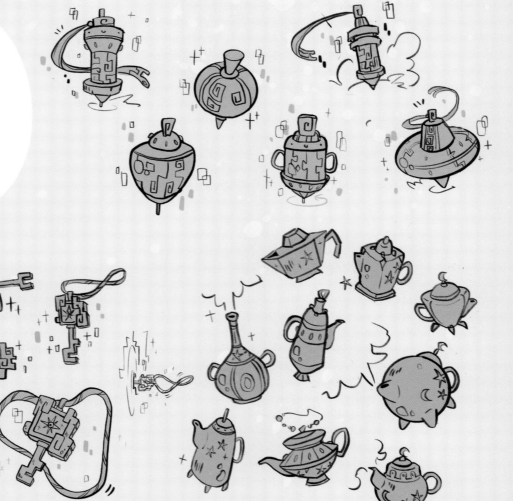

ACTING AND REACTING

Now that I've settled on a design that fits the brief and I'm happy with, I can start exploring poses. The body language of the character and interaction with any objects should be the focus through this part of the process. The central question I need to answer is what will my character's reaction to the artifact be? Are they surprised, afraid, curious, or something else?

I start with some loose sketches – it doesn't matter if the perspective is off or details are missing. We can fix everything later.

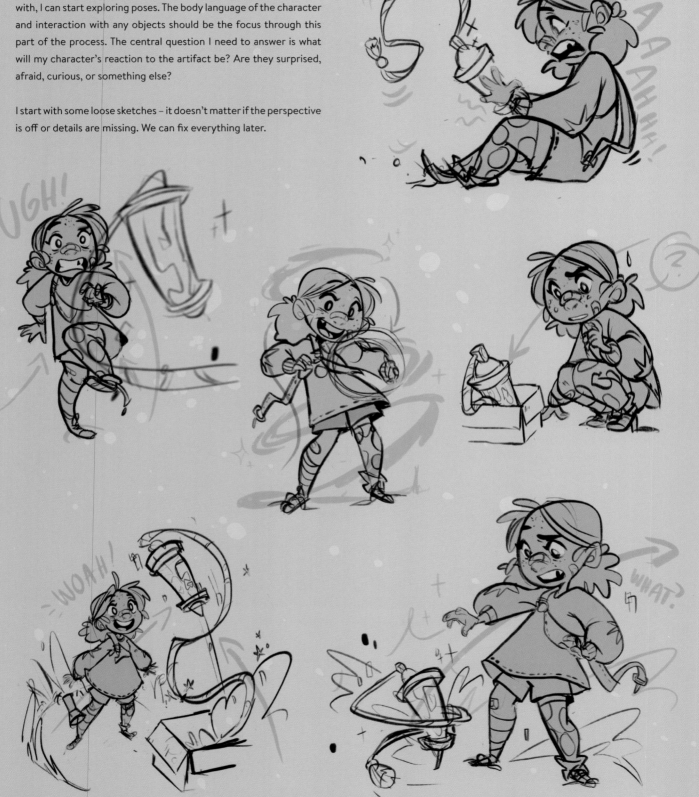

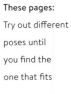

These pages:
Try out different
poses until
you find the
one that fits

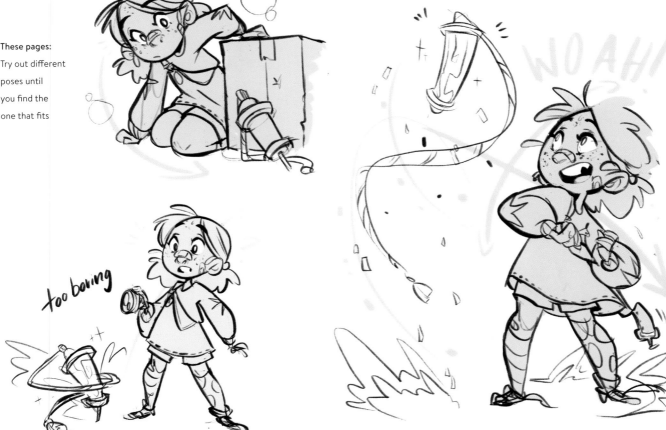

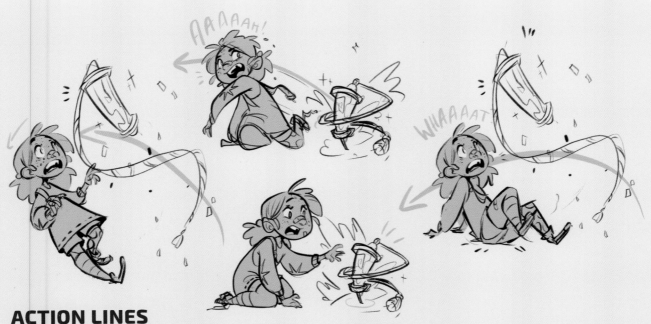

ACTION LINES

Adding action lines to an image reinforces the movement that you're trying to portray and can make a boring pose seem much more exciting. The action lines help me choose which pose to move forward with. The image I settle on shows my character falling on her bottom, surprised and overwhelmed by the artifact appearing right in front of her.

This page (top):
I modify the facial expression for the final sketch

This page (bottom):
The scene starts coming to life

"I CHOOSE THE COMPOSITION WITH THE STRONGEST EMOTIONAL CONNECTION BETWEEN THE CHARACTER AND THE OBJECT WHICH ALSO FITS THE STORY I'M TRYING TO TELL"

THE FINAL SKETCH

I choose the composition with the strongest emotional connection between the character and the object which also fits the story I'm trying to tell. For the final sketch, I decide to change my character's expression to something between surprise and amazement, instead of the fearful look in my earlier design. It's like you can hear the girl saying "woah!" I also think the perspective of this pose is definitely the most interesting I came up with.

BACKGROUND CHECK

It's time to start putting all our ideas and concepts together and explore composing the whole scene. What information do we want the background to convey? Earlier, I decided the narrative brief would be the young girl discovering the artifact in her grandmother's attic. I want to show the location is packed with old souvenirs and trinkets but still keep the focus on the character. I add objects to both the foreground and background of the image will guide the gaze of the viewer to the center.

THE SCENE

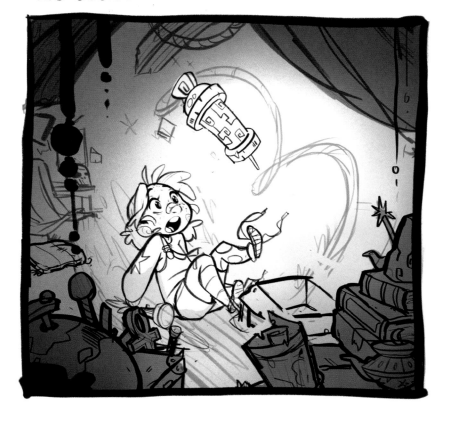

This page (top): I clean up the design and draw the final line art

This page (bottom): Gaussian blur is an easy way to give your design more depth

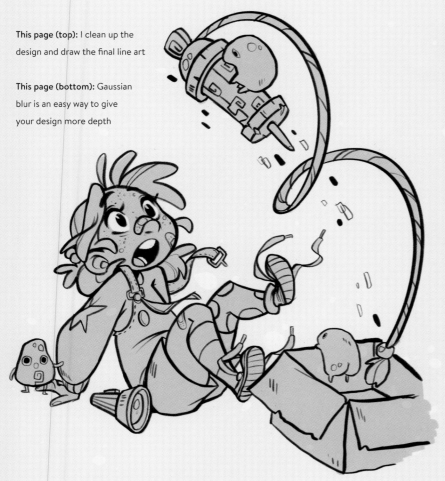

CLEANING UP THE MESS

With everything coming together nicely, it's time to clean up the sketch. I start by flipping the design for a fresh perspective – this helps make sure every part of the design is working well. I open up a new layer, choose my favorite line art brush, and create the finished design. The secret for dynamic line art is creating a variation of thick and thin lines. Get loose and just let it flow!

COMING INTO FOCUS

I'm happy with my character's line art, so I move on to cleaning up the background. As well as finalizing the line art, I add gaussian blur to the foreground objects so they appear out of focus. I add a thicker outline for the other foreground elements and lower the transparency of the background objects. These steps will automatically add depth to the line art.

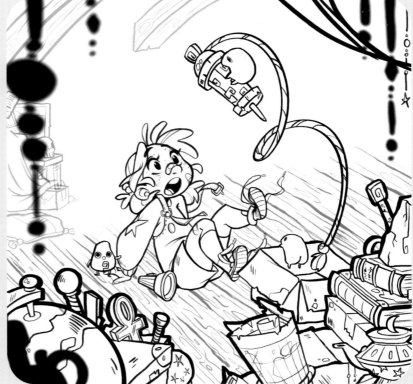

BRINGING IT ALL TOGETHER

Finding the perfect colors can be tough – choose a palette that serves what you're trying to convey in your scene. I take four of my favorite color palettes from earlier and place them alongside the artifact. I choose the scheme that best contrasts the cool color scheme I chose for the artifact. I create a new layer, under the line art, and add the flat colors to my character. I add some finishing touches and one final layer to overpaint some little details, add more highlights, and fix a few mistakes. And with that, the piece is complete!

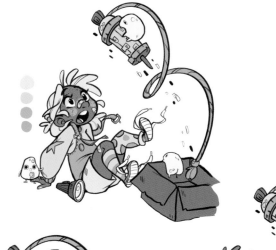

This page (top):
Choosing the color palette that best complements the artifact

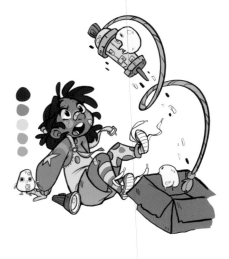
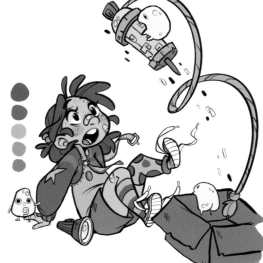

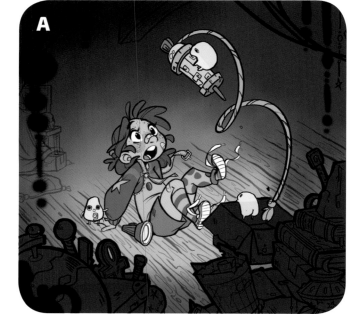

A: I want the character to stand out so I decide on cold colors for the background

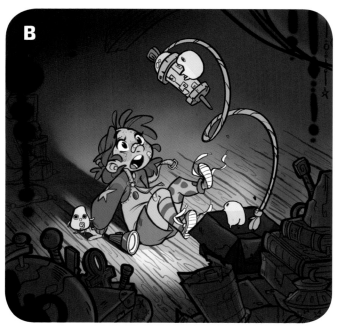

B: I keep the background color palette to monochromatic blues, adding a few dark and light highlights

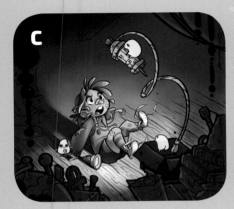

C: I add some shadows to the character to give the scene more depth

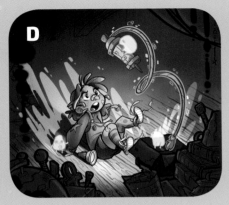

D: Special effects make the scene look more dramatic

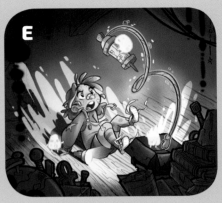

E: Finally, I add highlights and a warm color layer above the character for a coherent atmosphere

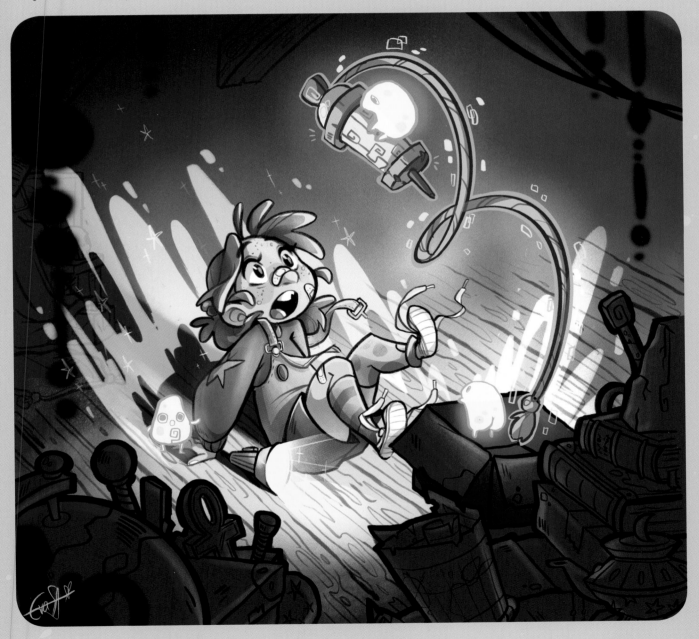

CONTRIBUTORS

MARTA ANDREEVA
Character designer
instagram.com/martenitza

TATA CHE
Character designer
tatacheart.com

LEA EMBELI
Character designer
and concept artist
instagram.com/leaem_illustration

NATHANNA ÉRICA
Illustrator at Disney
Publishing Worldwide
nathannaerica.com

 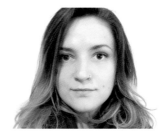

Marta is a freelance character designer with a love for animation. She has previously worked for studios such as Hahn Film and The SPA Studios.

Tata Che is a passionate character desginer in love with animation, currently working as a freelance character designer worldwide.

Lea is a character designer and illustrator from Serbia. She has worked as an illustrator for children's books and the past three years in animation.

Nathanna is an illustrator, paper artist, and visual development artist from Brazil. She is currently working at Disney Publishing Worldwide.

FATEMEH HAGHNEJAD
Illustrator and character designer
bluebirdy.net

LISANNE KOETEEUW
Illustrator and character artist
instagram.com/spookydraws_art

RAQUEL OCHOA
Freelance illustrator
rachelwinkle.com

CHAAYA PRABHAT
Independent illustrator
chaayaprabhat.com

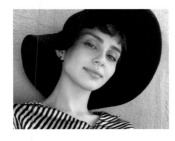

Fatemeh Haghnejad, also known as Blue Birdy, is an illustrator, character designer, and painter who combines traditional and digital techinques.

Lisanne is an illustrator and character artist living in the Netherlands. She's a concept artist by day and works on her own characters and stories by night.

Raquel is an illustrator from Spain, currently working in children's books. She loves drawing fantasy art and characters in harmony with nature.

Chaaya Prabhat is a children's book and digital illustrator based in India who has previously worked with Google and The Obama Foundation.

EVA STÖCKER
Senior art director in advertising
instagram.com/evayabai

THE SPA STUDIOS
Animation studio based in Spain
thespastudios.com

Eva Stöcker is a self-taught German designer and artist who works in the advertising industry and likes to draw in her free time.

The SPA Studios is an international animation studio based in Madrid, specializing in creating original animated feature films.

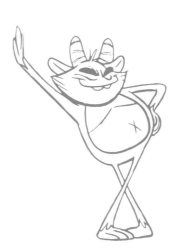 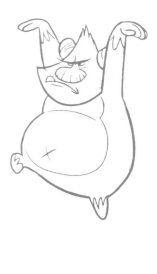

JUMPS
BY LORENZO ETHERINGTON

DIFFERENT *JUMPS*, LEAPS AND FALLS CONVEY A DIFFERENT *PERSONALITY* TO YOUR ACTION, THINK ABOUT WHAT YOU'RE TRYING TO *COMMUNICATE* - DANGER, FEAR, COMEDY, ETC.

LIGHT DROP

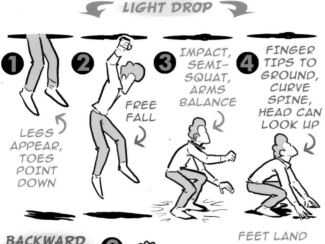

1
2 — FREE FALL
LEGS APPEAR, TOES POINT DOWN
3 — IMPACT, SEMI-SQUAT, ARMS BALANCE
4 — FINGER TIPS TO GROUND, CURVE SPINE, HEAD CAN LOOK UP

BACKWARD HOP

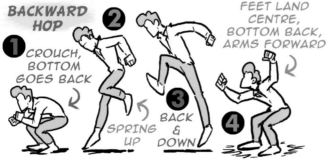

1 — CROUCH, BOTTOM GOES BACK
2
SPRING UP
3 — BACK & DOWN
4
FEET LAND CENTRE, BOTTOM BACK, ARMS FORWARD

SIDE LEAP
SKETCH A PERSPECTIVE BOX

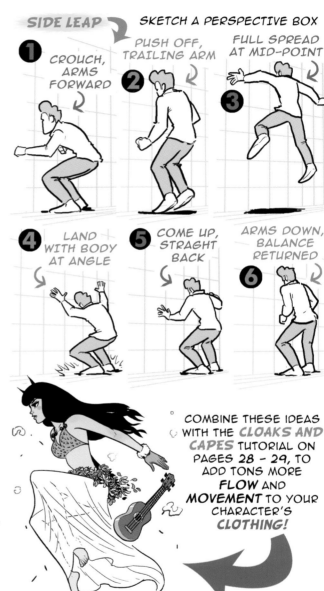

1 — CROUCH, ARMS FORWARD
2 — PUSH OFF, TRAILING ARM
3 — FULL SPREAD AT MID-POINT
4 — LAND WITH BODY AT ANGLE
5 — COME UP, STRAIGHT BACK
6 — ARMS DOWN, BALANCE RETURNED

COMBINE THESE IDEAS WITH THE *CLOAKS AND CAPES* TUTORIAL ON PAGES 28 - 29, TO ADD TONS MORE *FLOW* AND *MOVEMENT* TO YOUR CHARACTER'S *CLOTHING!*